WATERCOLOR DAY BY DAY

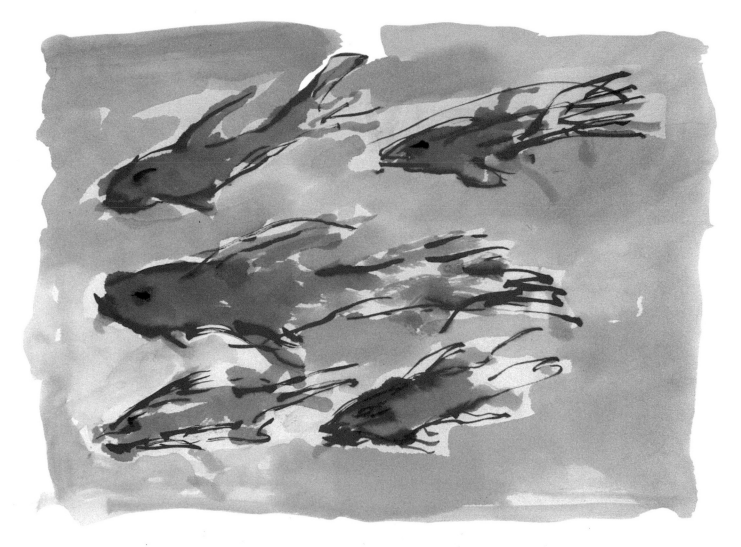

Michael Crespo, *Schooling*, watercolor, 8″ × 11″ (20 × 28 cm)

WATERCOLOR

Michael Crespo, *Two Shells*, watercolor, 19″ × 26″ (48 × 66 cm)

DAY BY DAY

Michael Crespo

WATSON-GUPTILL PUBLICATIONS/NEW YORK

I am indebted to all of the artists who generously allowed me to reproduce their work, especially the student artists, including those that do not appear in this book. They labored in my classes, survived my endless ramblings, and spurred me to responsibly guide them.

I thank my editor Mary Suffudy for cloaking me in such opportunity and leading me with insight, enthusiasm, and kindness. And I thank Sue Heinemann for her precise and inspired manuscript editing.

I thank my constant friends, Miriam, Louise, Juanita, and Ronnie, for their gentle, but emphatic encouragement of every inch of my progress.

I thank Mary, Buddy, Debbie, Bebe, Lea, and Lucye for the obvious—they're my family.

A wise and cherished friend, Leita, died as I was finishing this book. Her love and sweet encouragement will ever sound deep within me. Addio.

My wife Libby, my daughter Clare, my son Pablo, together compose the warm, loving presence that pervades everything that I do. I dedicate this book to them.

First published in 1987 in New York by Watson-Guptill Publications, a division of Billboard Publications, Inc., 1515 Broadway, New York, N.Y. 10036

Library of Congress Cataloging-in-Publication Data

Crespo, Michael, 1947–
 Watercolor day by day.

 Includes index.
 1. Watercolor painting—Technique. I. Title.
ND2420.C73 1987 751.42′2 86-26723
ISBN 0-8230-5668-6

Distributed in the United Kingdom by Phaidon Press Ltd., Littlegate House, St. Ebbe's St., Oxford

Manufactured in Japan

First printing, 1987

2 3 4 5 6 7 8 9 10/92 91 90 89 88

Michael Crespo, *Across the Arno*, watercolor, 4" × 3" (10 × 8 cm)

Contents

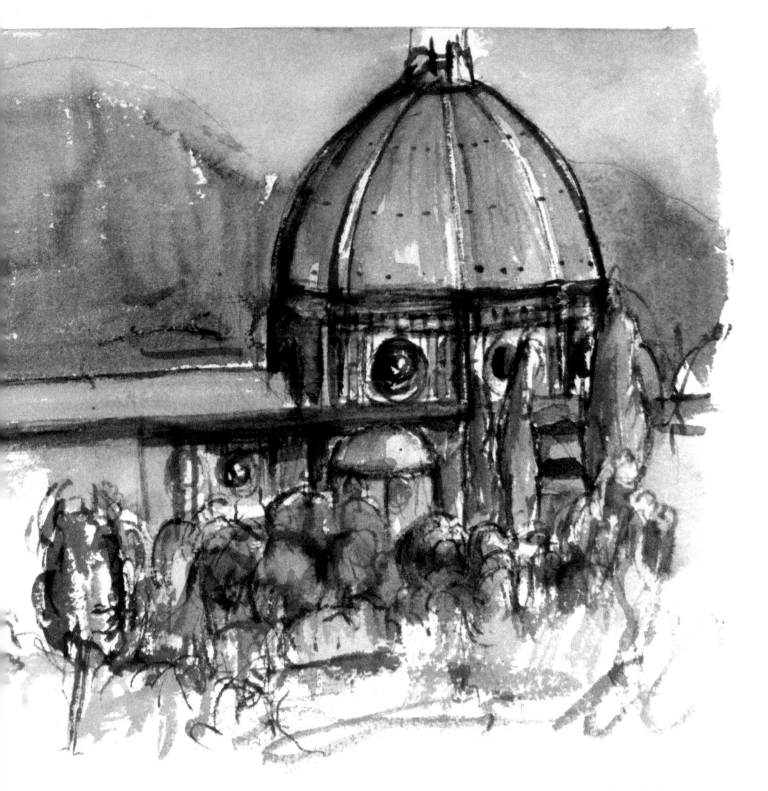

Michael Crespo, *Santa Maria del Fiore*, watercolor, 11″ × 14″ (28 × 36 cm)

Introduction

Many years ago I saw an exhibition of watercolors by the great English artist J.M.W. Turner. Until then I had viewed his watercolors only in books, and not many at that. I was drawn to one work in particular—*San Giorgio Maggiore: Early Morning*—a small painting done in Venice in 1819. In this watercolor a warm grayish-yellow tint washed across sky and water, settling on some boats to the right. The boats, architecture, and reflections in the lagoon all seemed effortlessly painted. It was obviously a moment of extreme insight for Turner, with a perfect understanding between eye and hand.

This painting reintroduced me to a medium I had deserted sometime during graduate school, when heroic oil paintings seemed my only pursuit. I had never considered making a watercolor for its own sake. That little Turner watercolor, however, spoke eloquently of the ephemeral, seemingly breathless beauty of this medium. It ignited a small passion in me, which led to many attempts at watercolor, with a lot of failures and a few successes—all outweighed by the simple, yet profound experience of doing.

I began writing this book after I had designed, taught, and redesigned a course in basic watercolor at Louisiana State University. These pages echo, in sequence and content, the course that I found most successful in introducing transparent watercolor to beginning students.

The information and exercises are presented in a day-by-day format, as if you were attending

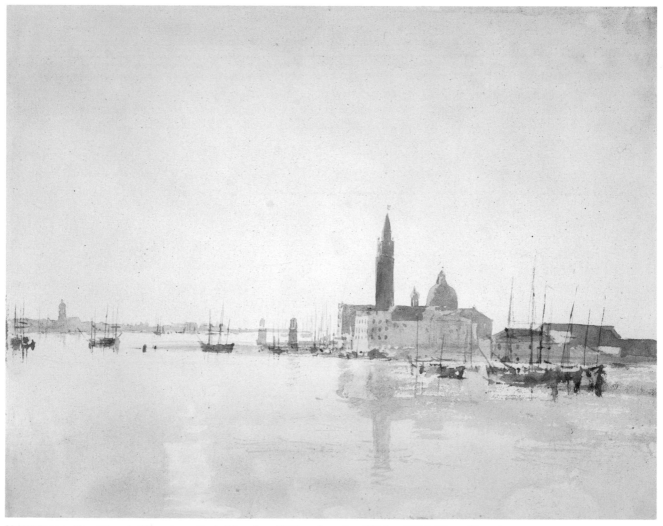

J.M.W. Turner, *San Giorgio Maggiore: Early Morning*, 1819, watercolor, 8¹³⁄₁₆″ × 11⁵⁄₁₆″ (22 × 29 cm), courtesy of the Trustees of the British Museum.

my classes. Technique, always touted as the great stumbling block of the medium, is filtered painlessly, yet thoroughly, through the assignments. Where applicable, I have suggested specific setups, as these can be as much of a design problem as the paintings themselves. You will note that the motifs are all still lifes and landscapes, as I believe that these subjects provide a greater variety of shape, color, and scale than the human figure does. All the exercises, however, can be adapted if you have access to a model.

Whatever the level of your experience, I suggest that you attempt to clear your mind and hand of all previous practices and expectations. Approach Day 1 with the enthusiasm and vigor of learning to crawl before walking. Each lesson will progressively improve your skills and knowledge, and—I hope—instill or reawaken a dedication to the medium.

MATERIALS

Before you begin, you obviously need to invest in certain materials. In addition to water, a brush, some colors, and paper are essential. Everything else can, with a bit of ingenuity, be fashioned from items you probably already have on hand.

My aim here is to suggest the most economical combination of materials possible, without sacrificing quality. It's true that pigments and brushes appear to be expensive, but consider how long these items last. Watercolor pigments are consumed at a much slower rate than oil or acrylic colors. And a good brush, properly cared for, can last for years.

Within the art-supply business, there is fierce competition, which helps to keep prices reasonable—provided you make the effort to shop and compare. Usually the best prices are found in the large mail-order catalogs. The main problem—unless you live near one of these establishments—is that you have to wait two or three weeks for shipment. If you want to get started right away, survey your local art-supply stores and look for the best prices. You may be surprised at how much prices can vary from neighborhood to neighborhood.

The materials you use will make a difference in your work, although not necessarily a difference in its quality. One painter may do exciting work with a stick, while another may employ the finest red sable brushes. Imagine beginning to paint with all the materials on the market at your disposal. You could simply edit and reedit your selection until only those best suited to your hand and expression were left. Obviously that's a

fantasy. At best we begin to collect the tools we can afford, decide whether they suit our demands, stow away the undesirables, lovingly care for the chosen, and purchase new wares to begin the cycle again. It's really not such a bad life. Besides, there's always the hope that a major turning point will arrive with each new brush, color, or new sheet of paper. And sometimes it really does come.

On page 14 you will find a list of basic materials needed to complete the lessons in this book. If you can afford more, buy more. If you can't, don't worry—you'll paint to your potential with these.

Brushes. In one art-supply catalog I counted 123 different watercolor brushes. It's certainly not a barren market. I suppose one could cradle an ambition to own all 123, but of the 40 or so brushes that I own, I actually use only three or four with any frequency. In the end there's only one that does the majority of the work.

When purchasing a brush, first make sure it's suitable for watercolor. Avoid the hog-bristle brushes used for oil painting or nylon brushes designed for use with acrylics. All too often shop clerks unfamiliar with their merchandise sell these brushes for watercolor use. Although they can be used for certain marks, they're not good for general application. They are stiff and nonabsorbent compared with the soft, synthetic-sable watercolor brushes.

The most popular brushes are rounds and flats, which come in a variety of hairs, including red sable, squirrel, camel, sabeline (a mixture of hairs), ox, and different synthetic bristles. Sizes usually range from a tiny 000 to 14, although, unfortunately, these designations may vary from maker to maker. There are also several other styles of brushes; most commonly used are bamboo, hake, script, watercolor fan, oval wash, and large utility wash brushes.

The finest brushes made are those of Kolinsky hair. I consider Winsor & Newton's Series 7 brushes to be unequaled. I own some small ones, but not the cherished no. 12, which sells for more than 150 dollars. I have used one and and can vouch for its superiority. I do use a no. 12 Kolinsky manufactured abroad for Utrecht Manufacturing Corporation. I'm perfectly content. It's a wonderful brush at one-third the cost. Yet even this alternative is not practical for the beginning student.

Enter the synthetic sable. Just about every manufacturer has a line of them. Although they do not absorb as much water as the natural sable, are usually not as well cut, and are in no way equal to the Kolinsky, they are extremely

The no. 12 round is the brush I have in my hand eighty percent of the time and by far the most easily manipulated.

A flat is great for broad strokes, applying large areas of color, and accurately pulling paint up to the outer edges of forms.

The bamboo is splendid for linear drawing and making shapes. When splayed it can produce wonderfully erratic textures.

The script brush functions almost solely as a line-maker.

The fan brush is used primarily for blending, but it also makes a good textural brush if you dab it.

The oval wash brush, thick with hair, can carry large amounts of color to the paper.

The large utility wash brush is essential to lay down a wash on a full sheet of paper.

At a certain point I had to completely ignore the fact that there was always another kind of brush to buy. I also gave up the idea that a new brush would revolutionize my stroke and solve my painting problems once and for all. While differences in size, shape, and type of hair do produce divergent marks, it becomes a major task keeping up with which brush does what—not to mention fumbling with twenty brushes in the course of one painting. In the end, the brushes you use are a highly individual decision. I've indicated the standard uses for some of the most common brushes, but their versatility should be explored with vigor.

affordable. Some experts shun them, but I find them a reasonable alternative. I even have a couple in my box I'm quite fond of. After years of testing many brands, my students and I recommend Winsor & Newton's Series 239 as by far the best of the synthetics.

In general look for a brush that is full with hair. Ask the clerk if you can wet the brush. (In most cases this will be allowed.) The brush is only as good as it is when wet. If it's a round, make sure the hairs taper to a fine point. The brush should also be somewhat resilient when pressed to a surface. Obviously, all this testing should not be wasted on a two-dollar brush. Essentially, you get what you pay for with watercolor supplies.

No matter which brush you purchase, its life span depends on how you care for it. Don't let it sit in water while you're painting, as the glue binding the hairs may erode. Clean it after each session using water only—no soap. Never carry or store your brush in a position in which the hairs could be bent and smashed. Try a bamboo placemat as a brush carrier—just roll your brushes up in it for protection. Or—to carry brushes in a paintbox—attach each brush with rubber bands to a piece of lattice wood somewhat longer than the brush.

Should a brush accidentally dry in a bent position, wet it; then, using mild soap as a stiffening agent, reshape it and let it dry. Wash the soap out, and the brush should be in its original condition.

Use your watercolor brushes only with watercolor pigments. Ink and other media can drastically alter and sometimes destroy their fineness.

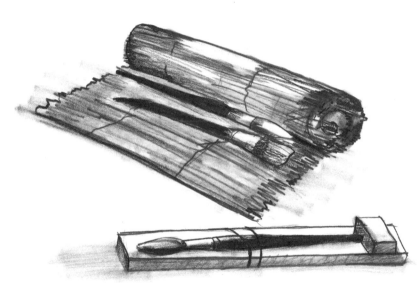

Brushes are usually protected well in the studio, as they sit up in crockery, porcelain vases, or tin cans. When you transport them outside to paint a landscape, however, the delicate and costly hair may be damaged. For protection, roll your brushes into a bamboo placemat and secure this with a rubber band. As I have some storage available in my portable paintbox, I utilize the wooden support pictured here.

Sponges seem indispensable for the watercolorist. I'd be lost without the common 3 × 4-inch (8 × 10 cm) cellulose sponge, readily available in any supermarket. It is perfect for blotting excess paint and water off your brush; it also makes a wonderful "brush" for applying texture and lifting paint. Moreover, a sponge like this is handy for cleaning palettes and for any accidental spills.

The other sponge shown here is a natural sponge, sold specifically for use in watercolor or applying makeup. It is generally reserved for applying or lifting paint.

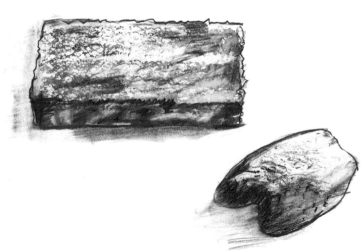

Paint. As a child, you probably played with watercolors, perhaps using the little round cakes glued to the back of a coloring book. Now, of course, you'll want to go up a bit in quality. Some excellent brands of cake paints are available. My wife often carries a small box of assorted pans of color when we travel abroad. They're compact and serve the situation well. I do not, however, recommend them for this course; instead, I ask you to purchase paints in tube form.

With tube colors, you can follow two different practices. I usually squirt half of the paint from a 14-milliliter tube onto my palette and allow it to dry. This I use in my daily work, activating it again and again with a spray of water before working. In this way I can have all my colors in "cakelike" form on my palette at all times, plus a liquid reserve in the tubes. This reserve comes in handy when I need to mix a wash or large amount of a particular color.

There are many fine brands of paint on the market: Winsor & Newton, LeFranc & Bourgeois, Rowney, Grumbacher, Holbein, Liquitex, to name a few. Most companies offer two series, which differ greatly in price: the more expensive professional line and the economical student grade. I

Shown here are 5 and 14 milliliter tubes of paint, as well as cakes of dry paint.

don't really think that your paintings will fade in a month if you buy the least expensive. The permanence ratings are usually slightly lower, but my twenty-year-old student works still look good, and I definitely painted them with the cheaper paints. Let your budget be your guide. Remember that you use very little pigment in watercolor painting, so your initial investment will carry you through quite a number of paintings. You won't be racing through tubes of paint as you might in an oil painting class. I've still not used up some colors I bought three years ago.

Basic Palette

Burnt Sienna

Alizarin Crimson

Cadmium Red Medium

Cadmium Orange

Cadmium Yellow Medium

Ivory Black

Sepia

Phthalo Blue

Ultramarine Blue

Phthalo Green

Paper. If any material can radically alter the look of a painting, it's the paper. Many fine papers, both domestic and imported, are available. Some of the great papers, well worth trying, are d'Arches, Fabriano, Whatman, and Saunders.

In the beginning, explore as many different papers as you can. During the course of this book, you might paint on twenty or so different papers. You might join with friends to buy a sheet of every paper you can find; then divide each sheet into the number of contributors so everyone has a sample to play with.

Paper can be purchased in blocks, rolls, or loose sheets. Blocks, which come in various sizes, are tablets of paper glued together at the edges. They are quite popular with students because they are compact and easy to transport. They also have a sturdy backing, which makes them ideal when you work outside, in the landscape. They are usually, however, a bit more expensive than buying by the sheet, and the choice of weight and surface is limited. I recommend that you buy paper in loose sheets so you can experiment with different sizes and surfaces.

Watercolor paper comes in several standard sizes. Imperial (22 × 30 inches, 56 × 76 cm) is the most popular size sold. Other designations are Royal (19 × 24 inches, 48 × 61 cm), Super Royal (19¼ × 27 inches, 49 × 69 cm), Elephant (23 × 28 inches, 58 × 71 cm), and Antiquarian (31 × 53 inches, 79 × 135 cm). Rolls of paper may be useful to those wishing to work larger than the sizes offered in sheets. But, like watercolor blocks, rolls are limited in variety.

As already indicated, you can choose different weights of paper. The weight of a ream—500 sheets of paper—determines the weight classification. Watercolor paper should be in the range of 90 to 300 pounds. I would not recommend any paper lighter than 90 pounds, and those heavier than 300 pounds are practically wallboard. You may have guessed that prices rise with the weight.

Paper is also available in different textures. The standard is cold-pressed or "not" paper, which has a moderately coarse texture. "Rough" paper, as the name implies, offers the coarsest texture; in contrast, hot-pressed paper has a smoother, less absorbent surface. These textures, however, vary some from maker to maker.

The most popular watercolor paper is 140-pound cold-pressed, but the choice is yours. Do purchase only 100 percent rag papers—anything less is not worth painting on.

Palettes and Containers. There are many varieties of well-designed watercolor palettes in the art-supply stores, most bearing the signature of a famous watercolorist. They offer wells for color, space for mixing, and portability. Some have snap-on covers; some provide brush storage. Beware of the light-plastic ones, as the paint wells tend to crack and leak.

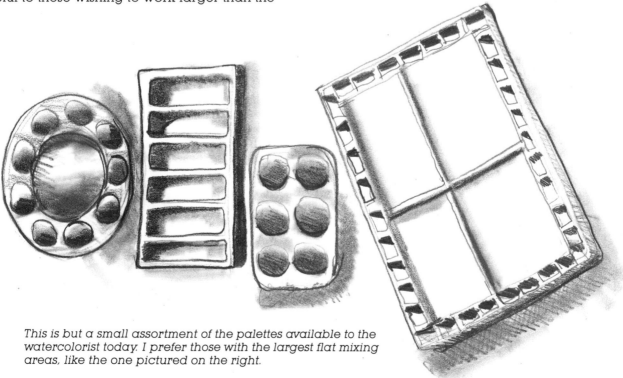

This is but a small assortment of the palettes available to the watercolorist today. I prefer those with the largest flat mixing areas, like the one pictured on the right.

Inexpensive porcelain butcher trays are now manufactured for the watercolorist. These make wonderful palettes, although mine seem to keep returning to kitchen use. Also available are paintboxes with a palette enclosed and space for tubes of paint and brushes.

Should a store-bought palette be too much additional expense, you can use any white, nonporous, flat surface. You might try plastic or porcelain dinner plates, or the plastic plates that accompany frozen microwave foods. I insist only that you have at least the equivalent of a 15 × 20-inch (38 × 51 cm) surface, or 300 square inches (762 square cm) of mixing space.

When you examine the watercolor supplies in an art store, or open a mail-order catalog to watercolor equipment, you'll find lots of "extras"—from brush quivers to nickled brass water bottles. If you have the spare change, collecting such accoutrements can become a lifetime passion. But, like most artists, you'll probably settle on an empty soda bottle and some pickle jars.

A student gave me one of these odd-looking containers, and I wouldn't be caught without it. The tub is divided into four separate water containers, so you have plenty of clean water while working on a painting. At the same time it takes up very little space on the painting table.

BASIC SUPPLIES

Brushes
no. 12 round (natural or synthetic sable)
no. 3 script (natural or synthetic)
1-inch flat (natural or synthetic)

Pigments (in tubes)

Required palette:
alizarin crimson
cadmium red medium
cadmium orange
cadmium yellow medium
phthalocyanine green
phthalocyanine blue
ultramarine blue
burnt sienna
sepia
ivory black
Chinese white (not to be used until Day 19, as the use of this color transforms transparent watercolor into opaque gouache)

Optional palette (for later explorations):
alizarin crimson
rose madder
Winsor red
Indian red
cadmium orange
cadmium yellow medium
lemon yellow
viridian
phthalocyanine green
chromium oxide green
ultramarine blue
cobalt blue
cerulean blue
manganese blue
violet
burnt sienna
burnt umber
yellow ochre
ivory black

Paper
140-pound cold-pressed paper, either in loose sheets or block form. Should you use a block, do not purchase one smaller than 10 × 14 inches (25 × 36 cm).

Additional tools
palette
2 jars or other container for water (one for clean water to paint with; the other for cleaning brushes)
1 synthetic sponge (the small size sold in supermarkets)
1 small sketchpad and drawing pencils
plenty of tissue

WORKING TIPS

Before you get started with the specific exercises, I have a few general recommendations about practical working methods as well as ways to increase your openness to experimentation. It's important to try different approaches and techniques to discover what works best for you.

Stretching Paper. Whether to stretch paper or not sometimes seems to be a whim of fashion. I can remember a few years back most experts recommended stretching every piece of paper that came into the studio. Now it seems to be more or less an option.

In the classroom studio situation, students tend not to want to stretch paper before class or carry around Masonite boards. Despite what I recommend, most either use blocks, leaving the sheet they're working on attached, or tape dry paper directly to the drawing table with drafting tape. These are not bad methods, but they do not take into account the reasons for stretching paper—which are to lessen the tendency of the paper to wrinkle when wet and to remove excess sizing from the paper, through soaking, so it is more absorbent. I solve the dilemma by using only 300-pound paper, which is heavy enough to remain flat when wet. A lighter paper really should be stretched, although some people work quite comfortably on 140-pound loose sheets lying on the table. I suggest that you stretch some and not stretch others, and compare the experiences.

To stretch paper, you'll first need a board to mount the paper on. I recommend one-quarter-inch untreated Masonite, cut larger than the piece of paper you're going to stretch. Soak the paper in cool, clean water for about ten minutes. A bathtub is perfect for this. Lay the wet paper on the Masonite and tape down all four sides with brown paper tape (sometimes called postal tape)—the kind with glue you have to lick, or, rather, sponge. You can let the paper dry, work on it wet, or re-wet it after it's dry. When the painting is complete, cut it off the board with a mat knife.

Another method of stretching is to mount the paper on wooden stretcher bars, commonly used for stretching canvas. Use thumb tacks to secure it to the wood. I sometimes staple the wet paper to Homosote, a porous building material.

Three methods of stretching paper: at the top, wet paper is stapled to soft Homosote board; in the center, the paper is thumbtacked to a wooden canvas stretcher; on the bottom, the paper is taped with postal tape to a piece of Masonite.

Use a scrap of paper to test your colors before you put them in a painting. Notice how lively the brushstrokes are on this "throw-away."

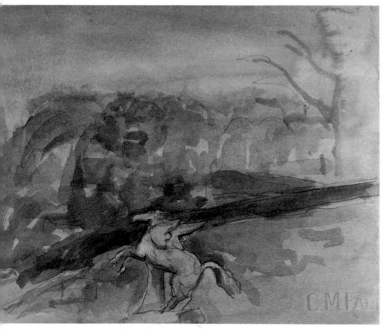

Michael Crespo, *Pegasus*, 11" × 14½" (28 × 37 cm)

This painting could never have been made solely from a photograph. I painted it one afternoon in Florence, as the clouds moved rapidly in front of the sun, making the light change drastically at erratic intervals. After laying in a light blue wash, I drew the statue and painted it, marking the shadows during moments when the sun peeked through the clouds. Next I sketched in the trees and foliage behind the sculpture. Soon, however, I realized that it was almost impossible to specify these forms which the light was constantly altering. After mixing some puddles of grayed blues and greens, I let my brush move across the paper, erratically spotting forms in much the same way as nature did that afternoon. Such a disorderly cadence would never occur with a camera, which records a very specific second in time.

Testing Color. Save scraps of your watercolor paper and use them to test every color you plan to put in a painting. By testing first, you'll save time lifting paint later. You may be surprised to find that these test strips sometimes exhibit better technique than the painting itself. On a test strip you may slap down color with a daring and spontaneity difficult to achieve in the one that "counts."

Lifting and Correcting Color. Although it's best to get your color right the first time, there is a way to change it once you've put it down. Always have tissue in hand; then immediately blot out anything you consider an error. If the paint has dried, apply clean water with a clean brush, using a slight scrubbing action. Then dab it dry with tissue. Depending on the color, you may have to repeat the process a number of times. Be sure to let the paper dry before painting into the "lifted" area. To lift an entire painting, try soaking it in a bathtub and then scrubbing. Once I came upon a friend of mine hosing down a painting in the driveway. The pressure of the hose made an excellent eraser.

Keeping a Journal. Among your basic supplies, I've asked you to purchase a small sketchbook. Use this as a journal. Make small sketches of subjects you want to paint. Also record, in paint and words, colors that you mix and may need down the road (you'll be surprised at how fast you forget a beautiful color). Put down bits of wisdom your teacher or fellow students impart, as well as bits of your own wisdom. As the years pass, a well-kept personal journal will surpass any book ever written on watercolor.

Using Photographs. Most of the time I can go through a student's portfolio and with a glance pick out the paintings made solely from photographs. If you don't want the "look" of a photograph, try to observe your subject directly. With direct observation, you're inevitably engaged in movement. Your eyes and body shift as you go back and forth from the subject to your painting. Natural light is also in constant movement, and even the subject may move at times. All this provides options—options not offered by the static photographic image.

Photographs, like paintings, are the result of an editing process. It makes no sense to edit what has already been edited. I recommend that you paint from the full detail of nature itself and use photographs only as recall aids.

Experimenting with Size. Try to vary the size of your paintings. Experiment with a very small painting—say, 3 × 4 inches (8 × 10 cm)—and a large, full-sheet painting, 22 × 30 inches (56 × 76 cm). Many times size will be dictated by the setup. Ask yourself: What size seems appropriate for the subject? What size do you feel comfortable with? Also consider the format. Explore deviations from the norm: nearly square shapes or exaggerated horizontal or vertical formats can be exciting alternatives.

Finding a Personal Expression. Unfortunately, watercolor has become plagued with superficial techniques and "winning ways." We lose sight of the fact that, like any artistic medium, it is meant to be stroked and coddled into each practitioner's distinctive voice. Of course, as a medium, watercolor has its own potentials and limits. But my point is that we *choose* to work in this medium because we think it can express our most individual vision.

Do not substitute flashy, mechanical techniques for your own personal touch, which indicates your will and desires. Learn the basics and revel in what you can bring to the medium. Be taught by everyone, but discover how to make your own paintings. Too many times students and artists wander off track, trying to second-guess teachers or judges, dishonestly posturing to capture that good grade or ribbon. I promise that a judge or teacher is more likely to reward your honest attempts. Watercolors are the poems of art, and poets should speak the truth.

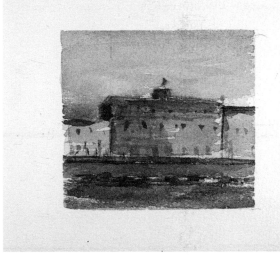

Michael Crespo, *Palazzo*, 3½″ × 4″ (9 × 10 cm)

Other factors—besides the subject—may determine the size and format of your work. The miniature work here arose out of the difficulty of painting in Florence during the tourist season. Setting up anywhere in the city with normal landscape paraphernalia immediately attracted a crowd of critics, who stood around, speaking about me, the painter, and my work as if I were not there. It was most frustrating. My solution was to mask off 3½ × 4-inch (9 × 10 cm) formats on small pieces of paper and slip my tiny paintbox into a characterless shoulder bag. Then, hunched over my work, I defied any eyes or comments.

The vertical posture of the two beetles, seeming to walk upright, is reinforced by this painting's unusual vertical format. Elizabeth Jenks has accentuated this upward thrust with emphatic black lines. Our expectations of scale are also disturbed by the background architecture, which gives the marching insects an almost human size.

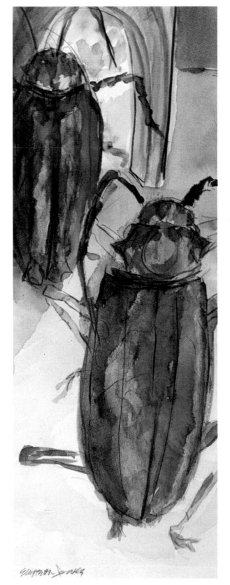

Elizabeth Jenks, student work, 16″ × 6″ (41 × 15 cm)

DAY 1
Brush Movement and Marks

In essence, painting a watercolor is simply making marks with a brush. Let's begin, then, with a look at how your brush does its brushing. I do not believe that there is one way to hold a brush. If you always held your brush in the same way, as you might hold a pencil, the marks would be very limited.

A brush can be moved with the fingers, the wrist, the lower arm, the whole arm, or the upper body. However ridiculous you think you might look twisting at the waist to produce a mark on the paper, it is a possibility. Experiment with different grips to discover what specific movements each allows or enhances. Variation in technique will produce variation in the marks you make, expanding your vocabulary and thus expanding your ability to express your ideas.

The exercises here will get you started. Use each of the different brushes you own to do each exercise. Work on inexpensive newsprint or other drawing paper to economize, but bear in mind different textures and weights of watercolor paper will give your marks a different look. Try to use all of your colors, including some two-color mixes. In other words, use this lesson as a chance to explore color possibilities as well as brushmarks. Also investigate the effect of transparent overlays by painting over your marks when they're dry.

Add a Stroke. Begin with a stamp, but this time leave your brush on the paper. Roll or stroke it in another direction to add another mark to the stamp. Vary the direction and manner of making the stroke, as well as the pressure you apply to the brush.

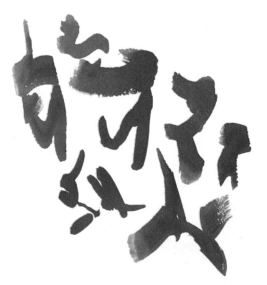

Compound Stroke. Stroke the paper in one direction (not a stamp, but a stroke). Quickly change your movement, then again. This exercise may seem similar to the previous one, but here you are concentrating on stroking, with more active, flowing movements of the brush. Do not make more than three strokes in a series, and try to form as many different configurations as possible.

Stampings. Load a brush with a color, not diluted with too much water. Make its imprint, or stamp, on the paper. As you do these stampings, vary the angle of the brush handle to the paper.

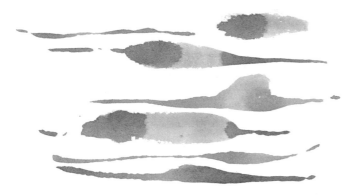

Tip and Heel. First practice painting lines with the tip of your round brush. Use an inklike consistency of paint to facilitate flow. Vary the thickness of the line by changing the pressure you exert as you move the line around the page. Next press the brush hard against the paper and drag it. Now you are utilizing the heel of the brush, which is next to the ferrule (the metal band joining the handle and the hair). As the pigment is used up, the brush will splay, leaving a trail of small, scratchy lines.

Numbers and Letters. Spontaneously paint numbers and letters as they come to mind. Vary the marks used to construct them. Repeat some of them, varying their construction.

Wet and Dry. This exercise simply involves the amount of water you use to activate your pigment. More water obviously makes the paint flow more, producing a more homogeneous mark. The "drier" the mixture, the more erratic the mark, due to the splaying of the brush. Later, we'll look more specifically at the drybrush technique (Day 13). For now, explore wet and dry modes by repeating all the previous exercises using various consistencies of paint.

Shape and Field. Again, use numbers and letters, but this time paint the space *around* the figure, leaving the number or letter paper-white. When you have had enough of numbers and letters, design some free-form shapes, making them as complicated as possible. Practice this exercise until you are fluent at painting the "negative" shape. This technique will prove very useful in days to come, for when you want white in a watercolor, it is best to leave the area white from the start.

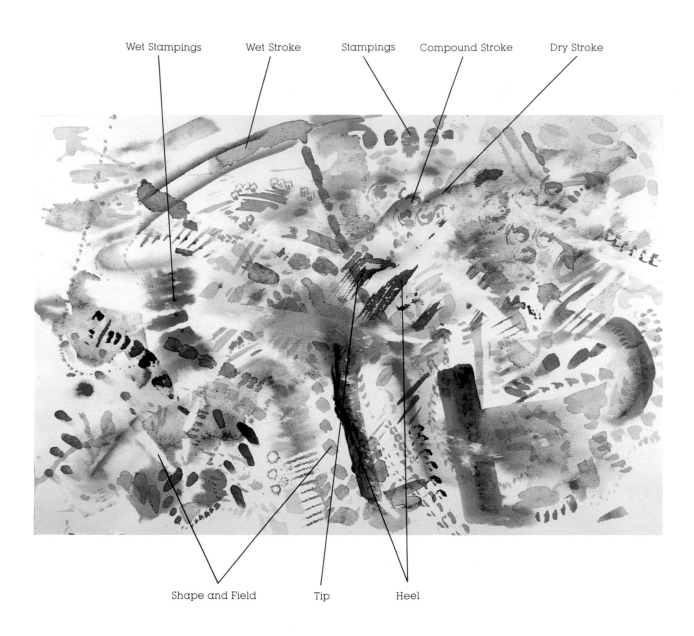

Wet Stampings Wet Stroke Stampings Compound Stroke Dry Stroke

Shape and Field Tip Heel

You may be surprised at the "pictures" you get when you combine different marks. This exercise by Royce Leonard has a liveliness and freshness often missing in more considered painting. The challenge is to carry over this energy into all your work.

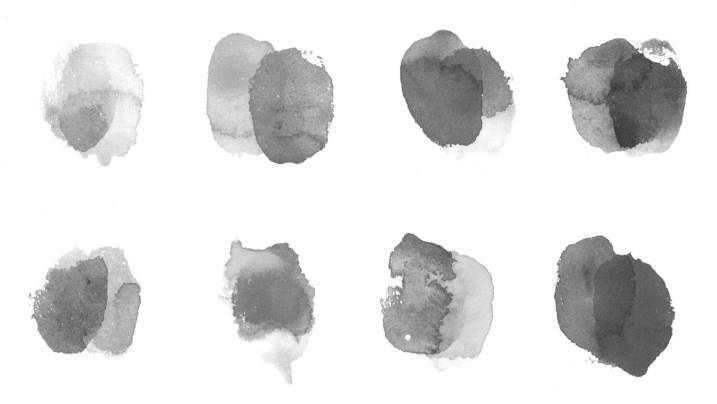

The transparency of watercolor pigment is probably its most notable quality. You can create intriguing veiled effects by layering one color over another. As a start, simply overlap your brushmarks. Here stampings of two colors produce a third color of darker value in between.

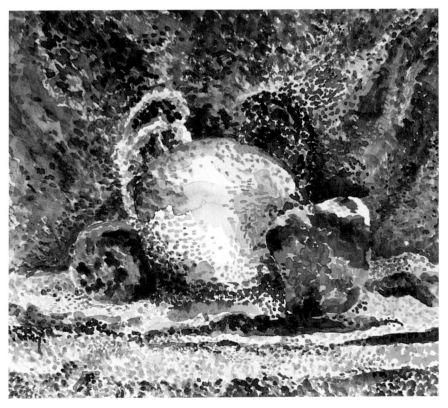

Lori J. Hahn, student work, 8¾" × 7¾" (22 × 20 cm)

Usually artists try to be as versatile as possible with their brushstrokes within a painting, but sometimes it can be constructive to limit your marks. Lori Hahn restrained herself to the point of obsession in this "pointillist" painting. She used the stamping mark of one brush to construct this glittering space. Of course the value and color had to be accurate to yield such a credible representation of light and volume.

Notice Lori's dazzling array of colors. It's the broken nature of the strokes, however, that gives the painting its texture and consequent shimmer. There are a few broader washes, especially on the vase, that help to soften the volume and lend a contrast to the dots. It seems almost impossible to keep jabbing your brush at the paper without at least making one other kind of mark!

On this sheet you can see the diverse marks produced by propelling the brush first with the fingers, then the wrist, then the arm. Royce Leonard may even have gyrated at the waist to produce the long, sweeping strokes from corner to corner. Remember, to travel across the page in a single stroke, your brush must be amply loaded with paint.

Another technique Royce has used is to lay down a stroke with dense pigment and then pass his brush, now saturated with clear water, over it. This creates the "ghost" effect around some of the dark strokes in this picture.

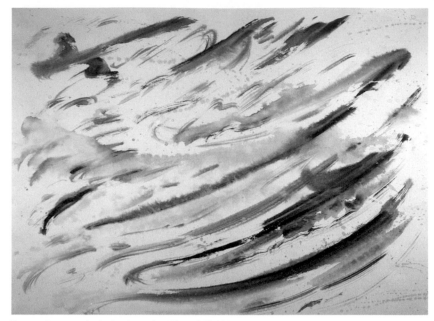

Royce Leonard, student work, 18″ × 24″ (46 × 61 cm)

The "shape and field" exercise is brought into play at the start of this painting. The banana plant—the figure—is left as white paper while the surrounding "field" is painted blue. The dark blue palm tree and green scrub foliage are then sketched in as shapes—additional figures on the field. Using this concept sets up the dynamics of this composition.

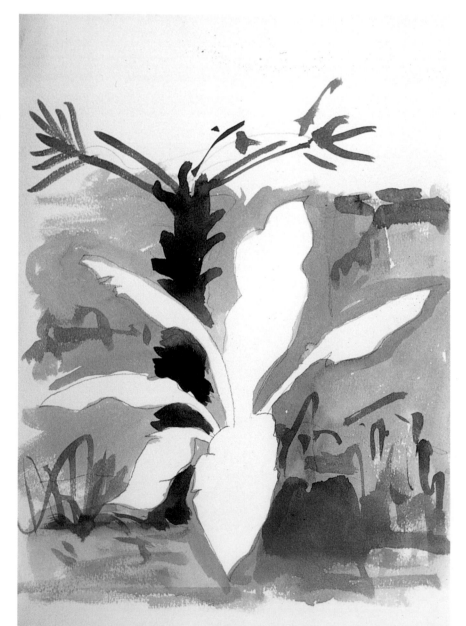

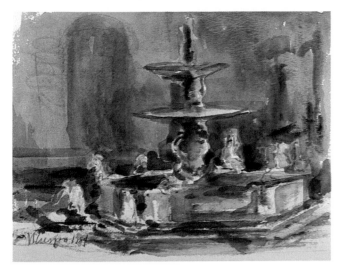

Michael Crespo, *The Fountain*, 11″ × 14″ (28 × 36 cm)

A lively, direct response with my brush freed this fountain from its architectural limitations. I began with a burnt orange wash to indicate the field, leaving the fountain and its sculpture white. Next I applied some quick, blue strokes to suggest the contrasting light. By brushing in dark, irregular shapes of brown madder and green earth, I began to realize the drama of the afternoon light. The "left-over" white shapes are just as important as any of the shapes I labored over. I feel that this painting expresses the essence of what I was looking at, while celebrating the exuberance of my brush and its tracks.

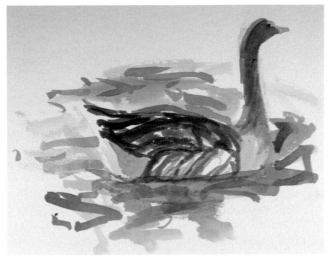

Libby Johnson Crespo, *French Goose on the Pond*, 9″ × 12″ (23 × 30 cm)

This sketch by my wife Libby was begun with a few broad markings to silhouette the goose's shape. Then compound strokes were quickly built into the feathery body and surface of the water.

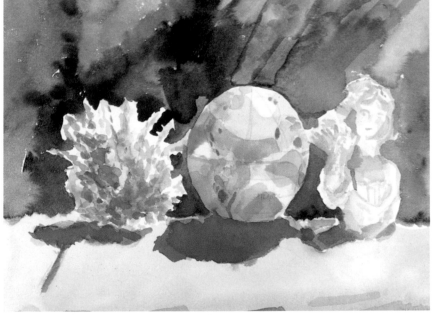

Leslie Wagner, student work, 11″ × 14″ (28 × 36 cm)

Leslie Wagner's foremost compositional concern was to indicate the contrasting edges of the three objects. To achieve this, she first laid in an irregular blue wash, forming the white shapes of the objects. She then painted a subtle rose wash on the ground plane, followed by staccato gray shadows, overlaid with dark red. Returning to the background, she mingled another blue with black, further emphasizing the chiaroscuro, or strong light-dark contrast. To complete the painting, she overlaid a myriad of stampings and compound strokes on the white object shapes, describing their volume and explaining their nature. The transparent buildup of color is clearly noticeable.

DAY 2
A Movement of Grays

It is important to experiment with mixing as many grays as you can. They are a vital aspect of color theory—all too often overlooked by students who, like most of us, are tantalized by purer hues. Working with the more neutral grays at first will make it easier for you to perceive changes in value—the lightness or darkness of an area. It can be much more difficult to sense value changes in lurid reds and bright yellows, because intensity is sometimes mistaken for value.

An important role of grays is their use as transitional color in a composition that also contains purer hues. The eye tends to move more slowly across grays than across pure hues. You can thus slow or speed the visual pace of a painting, depending on the amount of gray you use and how you position your grays. Moreover, grays serve as an excellent foil for pure hues, making the pure colors seem richer and more intense by contrast.

It should be clear that we are speaking here of gray as a color. If you think of gray only as a "black and white" mixture, it's time to expand your view. There are countless mixtures of gray. Just adding a spot of any color in your box to black will give you a diverse variety. You can also create varied grays by mixing the three primary colors: red, blue, and yellow (see page 28). Or combine complementary colors—red and green, blue and orange, yellow and violet—to produce gray.

As you explore these mixtures, you'll find that grays are not always neutral in the strict sense of the word; they can be warm, cool, bluish, greenish, or reddish. Occasionally, when your color mixing is at peak performance, you may achieve a perfectly neutral gray, which doesn't lean toward any particular hue. Don't be too excited about this. Remember, color is always *relative*. Your "neutral" gray will undergo drastic changes the minute you place it next to other colors.

To investigate the movement of grays in a picture, set up a still life with two or three white objects. Place them on a white ground, such as a white tablecloth against a white background. Direct a strong light on the objects, emanating from above right or left. In painting this still life, you'll be building a sequence of grays by applying one over the other in progressively darker values.

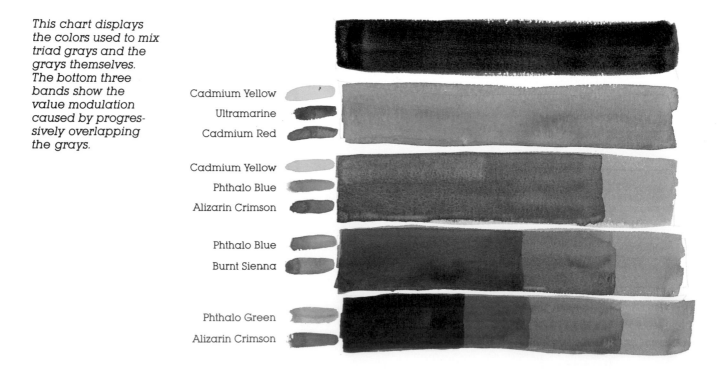

This chart displays the colors used to mix triad grays and the grays themselves. The bottom three bands show the value modulation caused by progressively overlapping the grays.

Cadmium Yellow
Ultramarine
Cadmium Red

Cadmium Yellow
Phthalo Blue
Alizarin Crimson

Phthalo Blue
Burnt Sienna

Phthalo Green
Alizarin Crimson

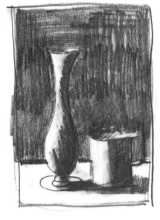

Step 1. Do quick compositional drawings in your sketchbook. Make value sketches to determine what the light is doing. Remember, just because you see a dark on an object, it doesn't mean that it will augment the feeling of volume in your drawing or painting. Look for the major value areas first. And don't clutter your drawing with dispersed, inconsequential darks.

Step 2. Scribble a light sketch on your watercolor paper. Move around on the page. Think of the relationship of forms. Don't worry about making mistakes, and absolutely do not erase anything. Erasures can produce unwanted textural effects. If you make an error, just correct it with a slightly darker line. Relax—this drawing is only a rough guide. As you add color and value, they'll soon visually consume the pencil marks.

Step 3. Mix a puddle of black. Don't economize on pigment—you want enough to cover the background with a truly dark value. Paint only the background. Leave the objects and the ground plane white. Then observe the sense of light established by the contrast of black and white.

Be sure to let the painting dry thoroughly. Problems often arise when you try to paint a transparent overlay over an area that is wet or even almost dry. For this exercise, make sure each step is completely dry—bone dry—before continuing. Use an electric hairdryer if you get impatient. Take a coffee break, or catch up on a novel. Or, better yet, work on another painting.

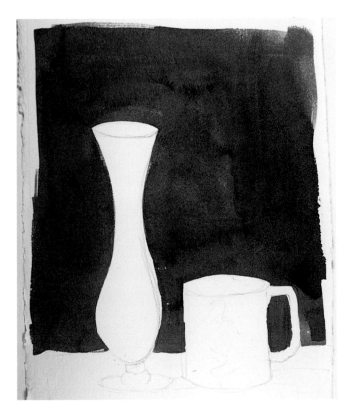

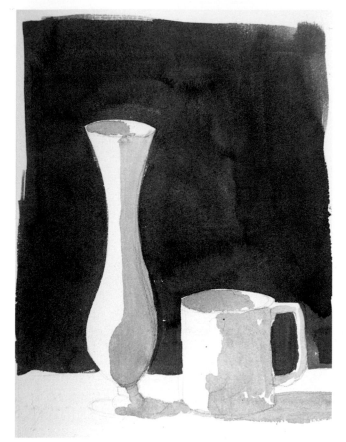

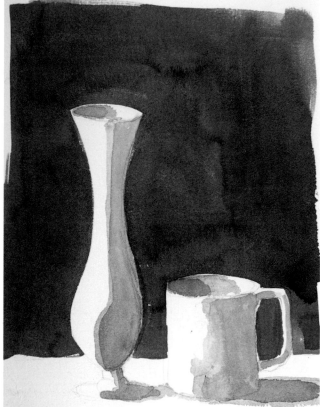

Step 4. On your palette, mix cadmium red, cadmium yellow, and ultramarine blue. Juggle the proportions until you get a gray as close to neutral as possible. Test your mixture periodically on a scrap of paper. It's neutral when it does not resemble any of its components. Overall, this color will be a brownish gray, rather than the traditional black-and-white version.

When you get a satisfactory neutral, add clean water to create a light value. The idea in this exercise is to get progressively darker with each mixed gray and to overlay color to aid in this progression. Now load your brush and paint quickly over the areas that you know will be darker than paper-white. Leave the ground plane white, except for the areas marked by shadow. Let everything dry.

Step 5. Mix your next gray from alizarin crimson, phthalo blue, and cadmium yellow—using hue variations of the primary triad. To make this gray darker than the last, add a little less water to it. Use it to enhance the sense of light in your painting. Also begin to establish transitional values by leaving some of the first gray wash visible. With each step, as you go darker, cover less area, leaving a trace of the previous color. Be quick and emphatic with your application. If something goes wrong, blot it out with a tissue. Again, let everything dry.

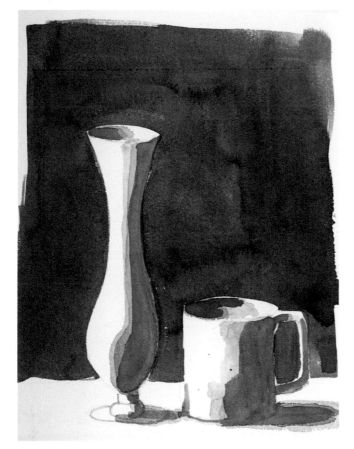

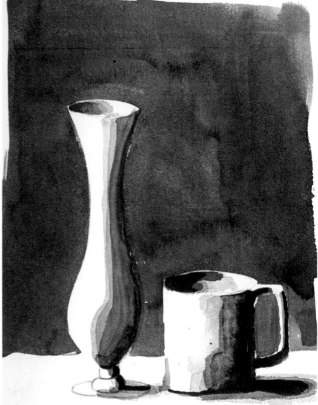

Step 6. Now mix a gray using phthalo blue and burnt sienna. This is a wonderful gray, much seen in watercolors. Essentially it's still a gray from the basic triad, as the sienna functions as a version of orange (red + yellow). Again, this color should be a little darker than the last. Use it to further carve out the volumes of your objects; then let everything dry.

Step 7. Now make a wonderful dark using phthalo green and alizarin crimson. At full strength this luxurious dark, with its hint of either red or green, appears blacker than black. Use it to emphasize the extreme darks in your setup. There—you should have a dramatic, volumetric depiction. Stand back and see if it doesn't work even better at a distance.

Here are some alternative grays you can make with an expanded palette. Note that manganese and cerulean blue tend to be very grainy pigments and produce a beautiful leathery texture found only in watercolor.

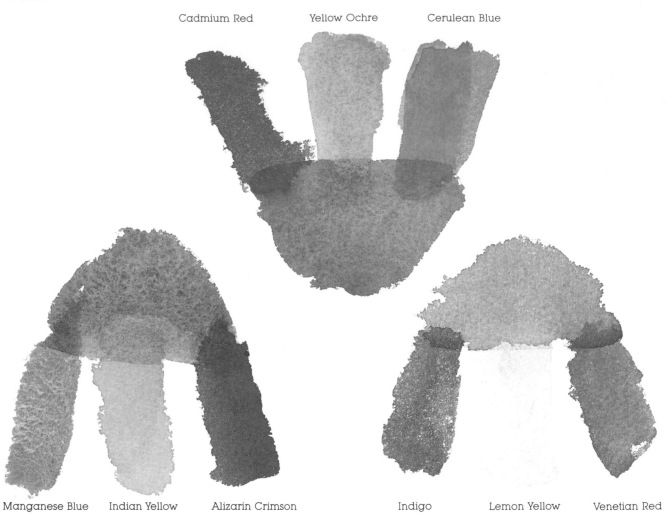

Cadmium Red Yellow Ochre Cerulean Blue

Manganese Blue Indian Yellow Alizarin Crimson Indigo Lemon Yellow Venetian Red

Gloria Jalil's stabbing brushmarks cause correspondingly abrupt value transitions. It is intriguing that despite the strict, recipe-like structure of this exercise, she has kept a sense of her own voice in this painting. I hold this virtue high in your responses—whether the problem is successfully solved or not.

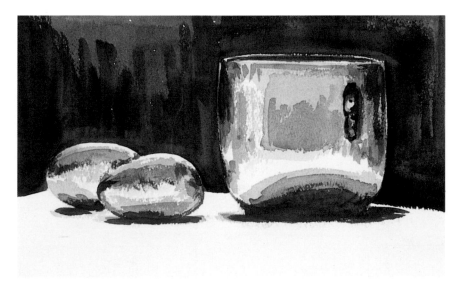

Gloria Jalil, student work, 7″ × 11″ (18 × 28 cm)

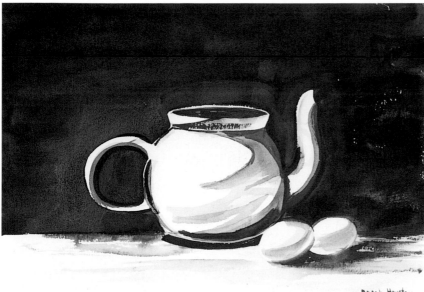

This painting by Deana Houston exhibits economical brushwork in the few bold marks used to describe the internal planes of the objects. But Deana has expanded her brush repertoire in the surrounding space. A drybrush stroke accents the dark in the top rim of the teapot, while characteristic blooms from wet paint on wet paint suggest shadows on the ground plane.

Deana Houston, student work, 12″ × 16″ (30 × 41 cm)

Carrie Alexander's grays move off neutral, giving the painting a slightly richer color sense. Notice that the black Carrie chose appears slightly blue. Blacks usually have a color base, which may be more obvious when the pigment is diluted. Also notice that one of the grays in the coffee pot has a greenish tint. This is probably the phthalo blue and burnt sienna mixture, which can be difficult to lure away from green.

Now look at the whites that run down the center of the pot, which do much to give the form volume. Keep in mind that whites generally project from the picture plane. In this painting they are located on the part of the pot closest to the viewer, so the rest of the pot seems to recede, away from them.

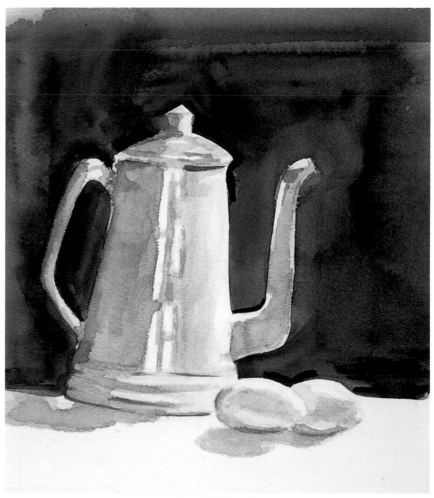

Carrie Alexander, student work, 11″ × 12″ (28 × 30 cm)

DAY 3
The World of Shape

There are two kinds of shapes: geometric and amorphous. Geometric shapes are just that—geometric. Squares, circles, rectangles, spheres, triangles, and tetrahedrans in part make up this category of named, recognized shapes. In contrast, amorphous shapes do not have a recognizable identity. These free-form shapes are often expressive and lyrical.

Shapes can also be defined by their role in a composition. The objects—trees, people, cups, whatever—are all considered *positive* shapes. *Negative* shapes are formed by the spaces between positive shapes or by a positive shape's relationship to the edge of the paper. These two shape types are also referred to as figure/field, yin/yang, or figure/ground. Most people tend to recognize only positive shapes, so it's a good idea to practice shifting your vision to the often neglected negative shapes. Remember, in the flat, two-dimensional world of painting, all is equal.

I would like to inject a third compositional shape, which I call an *immigrant* shape. This shape crosses the boundaries of the positive-negative relationship and borrows its existence from both. An example is a shadow shape on the dark side of an object and the ground plane.

An important concept to consider in compositional shape-making is scale. It's a simple idea. Make some big shapes, then some small shapes. A large shape is not large until you compare it to a small one or vice versa. Scale can also be a factor in suggesting space. Study the cartoon shown here.

Also think of shapes as part of a compositional pattern. By repeating or echoing shapes throughout a picture, you can introduce rhythms and arabesques, carrying the viewer from point to point.

Basic Types of Shape

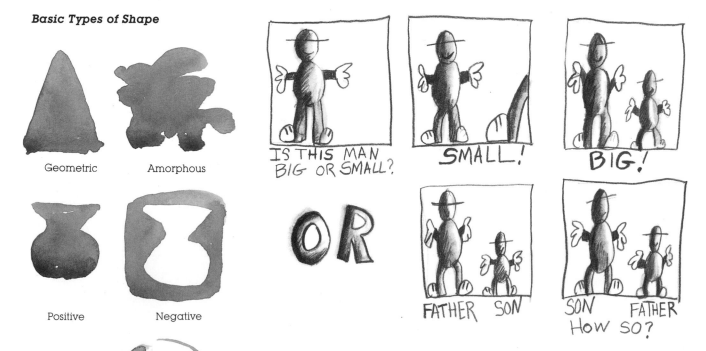

Geometric

Amorphous

Positive

Negative

Immigrant

IS THIS MAN BIG OR SMALL?

SMALL!

BIG!

OR

FATHER SON

SON FATHER
HOW SO?

In art, opposing concepts can exist simultaneously. You surely figured out that the tiny father is farther from the viewer. Ah, perspective! This is the beginning of the irony of working in two dimensions but trying to create the illusion of three dimensions.

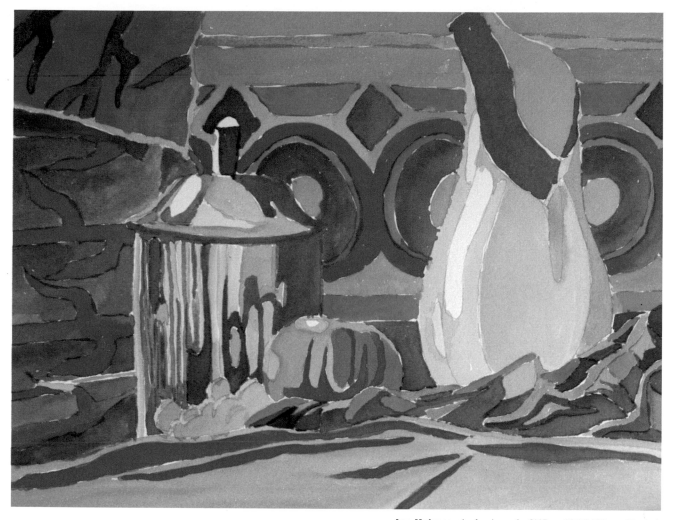

Joe Holmes, student work, 9½″ × 12½″ (24 × 32 cm)

For today's exercise, set up a well-lit still life containing at least fifteen objects and as many draperies as you can pile on. Or use a crowded interior space. With your pencil, begin drawing shapes directly on the watercolor paper. Try to approach this with reckless abandon, freely interpreting the setup. If you can envision the still life as a huge, flat field, it may help you reestimate what you are looking at. As you make each shape, ask yourself, "Is this shape interesting? Or is it dumb and dull?" Fill the page.

Now take colors, many colors, and start filling in the shapes. You do not have to adhere to the local color of your subject. Indeed, you might dismantle your still life, so as not to be intimidated by the color before you. Employ a great variety of intense colors and a full value range (from paper-white to dark). Also "pattern" some of your colors. By repeating a bright red in different places, you can make the eye follow its path.

At first, just randomly place your colors. Soon you will "sense" your next move. Follow these sensations to completion. Remember, you can always modify a color by overlaying another.

Joe Holmes took a realistic approach to the still life, while constructing it with a great range of shapes and colors. Compare the geometric shapes in the background with the amorphous shape of the blue and purple drapery, as well as the positive and negative relationships in the vase. Also notice how Joe has used shape and color variations to depict the reflective qualities of the copper pot on the left. Here we see pockets of smaller shapes within larger ones. To the eye, a bunch of small shapes, or a bunch of large shapes, mass together as a single shape—another compositional weapon to consider.

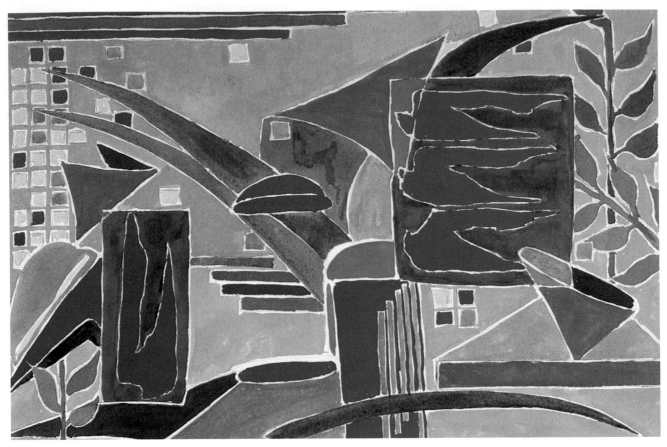

Bryan Murphy, student work, 12″ × 16″ (30 × 41 cm)

By assigning so many large shapes the color orange, Bryan Murphy has established a field, with all the other shapes floating in it. Geometric shapes dominate, but there are also plant and bird shapes, repeated throughout, which take on a narrative role. These images were not blatantly evident in the setup; Bryan made the transformations.

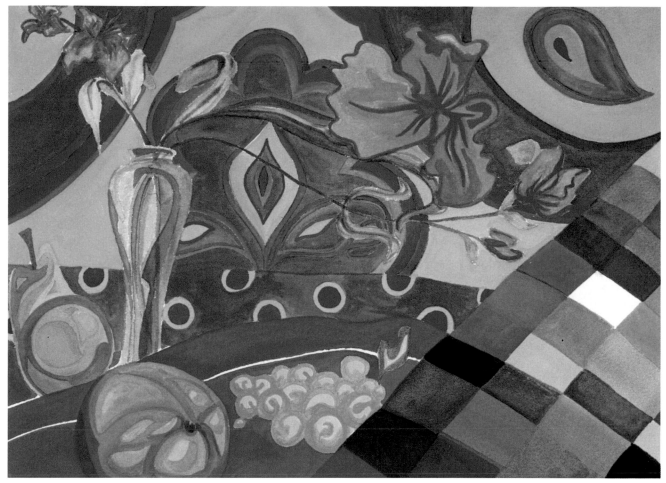

Gloria Jalil, student work, 10" × 14" (25 × 36 cm)

In this whimsical world, all the still life objects are intact. Gloria Jalil has playfully distorted the objects in her shape-making and flung them into a tense, awkwardly positioned world. Notice how she has isolated one white shape: it rests in the checkered quilt, which also offers a startling contrast to the rest of the painting. The flowers, too, create an interesting tension. The blue flowers on the left are rendered realistically, while the looming yellow flowers on the right are flat and more abstract.

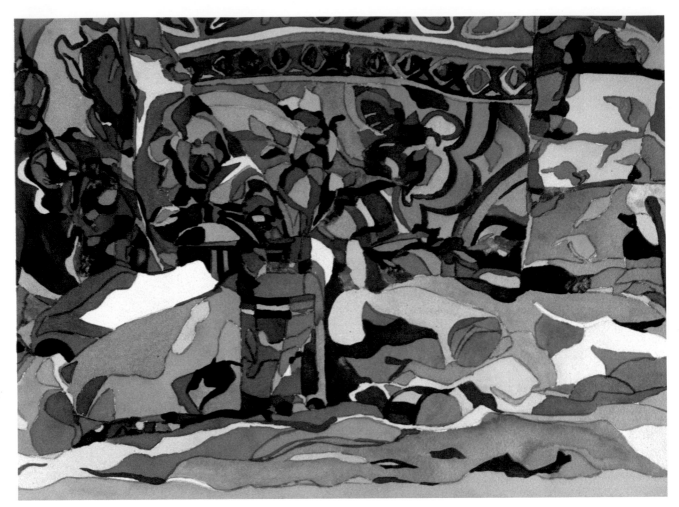

Christy Brandenberg, 12″ × 16″ (30 × 41 cm)

Christy Brandenberg has a gift for inventive shape-making. Her shapes have been highly abstracted, yet the three-dimensional integrity of the still life remains evident. Amorphous and immigrant shapes dominate the composition, color is widely varied and well placed, but the most striking aspect is the manipulation of scale. The center of the painting is tightly congested with small shapes, while the surrounding edges are more relaxed, as the larger shapes seem to drift in the space. This is not only a juxtaposition of scale, but also a contrast of shape character.

Christy also makes fine use of the yin/yang principle. In the zone with the large shapes, she has included small accents and vice versa. Finally, notice how the color blue weaves a pattern through the space, carrying the eye from foreground to background.

Deana Houston, student work, 12″ × 16″ (30 × 41 cm)

The soft, rhythmic edges of many of the shapes and the undulating color within them give Deana Houston's work a distinct personality. It's wonderful how shapes can suggest different tactile and emotional qualities, as well as the individuality of the artist making them. Deana has chosen to make most of the shapes the same size, which keeps the composition close to the surface, in a very shallow space. This is not a criticism. Composition is a matter of choice. Deep space may be a more popular format, but it is not the only one, or necessarily the better one.

DAY 4
Color Plans

Although we may clothe objects in color, color is essentially abstract, with properties of its own that have nothing to do with the object. In painting, color is remarkably spatial: red advances, blue recedes. It is also emotional: red agitates, blue soothes. Color can be dark or light, bright or dull. It can seem large or small. Most important: color is always relative. Just how dark, how red, or how soothing a color is depends on the relation of that color to others around it.

Color theory will give you insights into color, but there is no substitute for working knowledge. Experiment as much as you can with color. Explore how the same color changes in ap-

pearance not only when you place it next to different colors, but also when you apply it on various papers, or perhaps when you change its shape.

It's a good idea to have a very general color plan before you start to paint. Don't make your goals too specific, however—you should feel free to explore many possibilities. Consider adopting one of four basic schemes for color composition that I have found particularly useful:

- varied color shapes on a gray field
- gray shapes on a single-color field
- varied color shapes on a single-color field
- gray shapes on a gray field

Color Wheel. *The colors on the left are warm; those on the right, cool. Red and green are the transitional zones: warm yellow-green meets cool blue-green, and warm red-orange meets cool red-violet.*

Look at the examples below and on the next three pages. In all these plans, there is a dominant color or color group. Wander through a museum or peruse an art book and observe how often a particular color dominates a composition.

Within your basic plan, you must consider various properties of color. Already you've gained some sense of the importance of value in creating a feeling of space and volume. Now we'll look at the effect of color temperature.

Just like your soup, color runs from hot to cold and every designation in between. To understand this, look at the simple color wheel shown here. The primary colors red, yellow, and blue combine to form the secondary colors orange, green, and violet. Yellow, orange, and red are considered warm colors, while blue, violet, and green are cool. Red, however, can enter the cool domain as it approaches violet, and green can warm up as it approaches yellow.

Bear in mind that everything about color is relative. In a painting filled with "warm" colors, it's possible for an orange to appear cool. Similarly, you might find a warm blue in a field of cold colors. Mixed grays take on the temperature of the dominant hue. A blue-gray will be cool, a yellow-gray warm. In practice even "neutral" grays lean toward one temperature or another, sometimes taking on the characteristics of surrounding color and sometimes opposing them. To learn more, turn to the exercise on page 41.

Plan 1: Color on a Gray Field.
Small shapes of various colors are situated in a gray field. It is not necessary for the field to be a solid gray; it could contain many variations of gray.

Alice Verberne's painting exemplifies the color-on-gray plan. The grays dominate the background and also move through the sculpture fragment, the shell, the vase, and down onto the ground plane. Blues, reds, and oranges are the subordinate colors in this gray field. Another strong compositional element to note here is the dramatic placement of the extreme darks.

Alice Verberne, student work, 19″ × 15″ (48 × 38 cm)

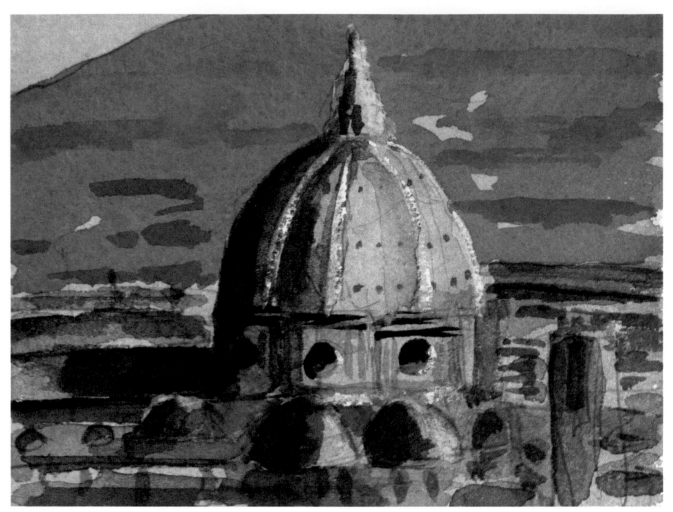

Michael Crespo, *Il Duomo*, 5½″ × 8″ (14 × 20 cm)

Plan 2: Gray on a Color Field. Here varied, small gray shapes are engulfed in the blue hue. The blue field need not be homogeneous—it could be an assortment of many different blues. And, of course, the field doesn't have to be blue; it could be any other color in the spectrum.

In my painting the blue-greens link with the major blue to form the dominant color field. Because the rest of the colors in the painting are decidedly gray, the blue-greens are "forced" to join their blue relatives as a mass. The grays, however, are varied, moving from the cool gray lights to warm gray shadows.

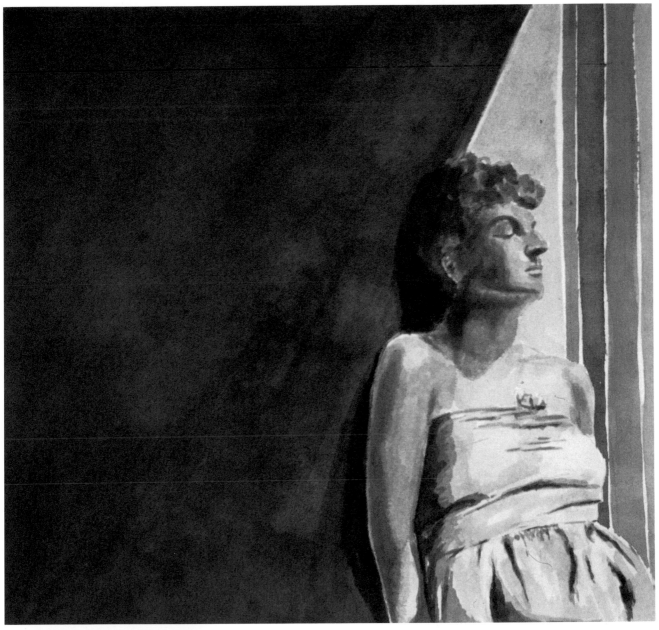

Bryan Murphy, student work, 12″ × 11″ (30 × 28 cm)

Plan 3: Color on a Color Field. *Now the scale is established by a number of smaller color shapes on a dominant red field. Again, this field need not be a solid red: it could be any spectrum color or a variety of reds.*

Bryan Murphy's poignant figure study offers variation of the color-on-color plan. Here the small color shapes are locked into the field as a unit, rather than dispersed across it. The field is the dark blue wall that the woman is leaning against, her even darker shadow, and her dress, with which the shadow connects. Although the dress is warmer than the wall, it is nonetheless a blue-green, and, since the only other colors are fiery warms, it joins its analogous neighbor (the color adjacent to it on the color wheel). The smaller colors "on the color field" include the yellow, orange, and red stripes on the right and the woman's skin tones and hair color. The two masses connect, like a handshake, at the point where the arm moves into the blue and the dress moves into the warms.

This painting also reveals how temperature can work. The dominant cool colors make the subordinate warms seem much hotter, and vice versa.

39

Plan 4: Gray on a Gray Field. *This plan is similar to the third one, but now grays constitute both the shapes and the field. Note how in an entirely gray situation, the various grays appear as different colors. The same grays placed in a composition with some pure colors would quickly be reduced to more neutral grays.*

Ellen Ellis has defined a dominant field of grayed red drapery. Within the skull you can find some green-grays, blue-grays, and neutral grays. The touches of grayed violet within the reddish-gray field tend to connect visually with the grays in the skull, setting up some opposition to the field. In a painting of so much grayed color, however, there is far less opposition between the colors and the field than in the other plans.

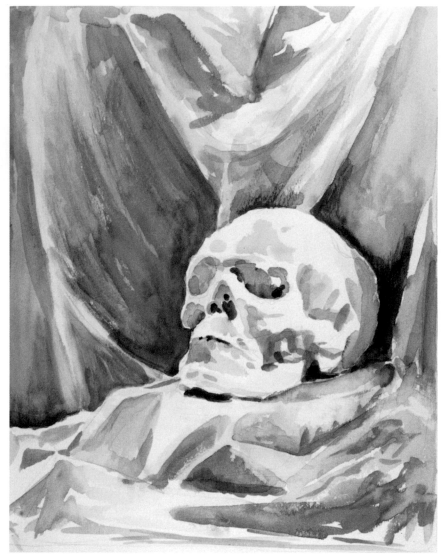

Ellen Ellis, student work, 13″ × 10″ (33 × 25 cm)

TEMPERATURE WARM/ TEMPERATURE COOL

For this assignment, set up two still lifes. Keep them simple. I recommend two objects on a drape. A piece of fruit and a small pitcher or a seashell would be ideal. In one setup, use only warm colors and light the arrangement with an incandescent lamp. For the other, choose cool colors and, if possible, restrict the light to cool fluorescent. You might also try painting the cool subject in early morning sunlight and the warm one in the hot afternoon. Be sure to light your still life dramatically, with the light clearly explaining the objects and making strong, shapely shadows.

Essentially, the task is to paint from your setups, one cool and one warm. I do, however, want you to depart somewhat from the local color. In the warm painting, use as many warm colors as you have in your box or you can mix. Even if you don't observe all these colors in your still life, try them. Aim for an overload of color within the dominant warm temperature. Do the same for the cool painting.

You may use cool colors in the warm painting and warm in the cool, but keep them to a minimum so they don't confuse the dominant temperature. A few cool notes within a warm scene, however, can provide an important scale reference; spots of blue among sizzling warms, for instance, can make the warms hotter by contrast.

One potential trouble spot is the painting of shadows in the warm scene. Shadows generally appear cool, whatever the color of the plane they are on or the light. Everyday remarks, such as "Let's get out of the warm sun into the cool of the shade," confirm this. In a painting, however, anything is possible. You could create cool, purple shadows in your warm painting to provide a temperature contrast, or you could make deep red-orange shadows, which would be slightly more unusual. For the experience, try to find as many warm darks as cool darks.

As you paint, don't worry too much about technique. Use what you've learned so far about working directly and building transparent overlays, not to mention varying your brushmarks. At this point, let technique be born of necessity. Mistakes are inevitable, but also invaluable in discovering how to make the medium speak your language.

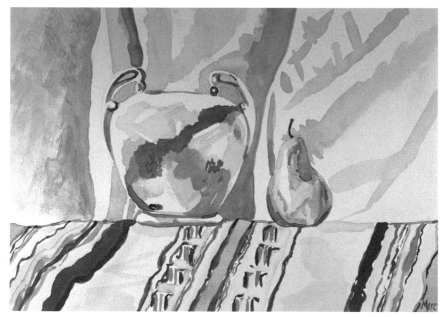

There is no doubt of the heat in Marcy Blanchard's painting. She exaggerated the colors appropriately to explore the range of the warm spectrum. Her casual brushwork gives the painting a spontaneity that complements the sunny color.

Marcy Blanchard, student work, 10¼" × 14½" (26 × 37 cm)

Jonathan Drury has made very thoughtful color choices in his warm painting. He has kept the heat somewhat subdued and tamed the yellow field by introducing some warm grays. Notice the visual pull of the isolated red area on the large apple. This is but one of three quietly dramatic moments Jonathan has created within the row of apples. Also notice the bold, green contour around the apple on the left and the almost black shadow cast on the apple on the right. These last two are quirky marks, but very effective compositionally. They remind us that this is really a painting, not a rendering, filled with the instinct and daring of its maker.

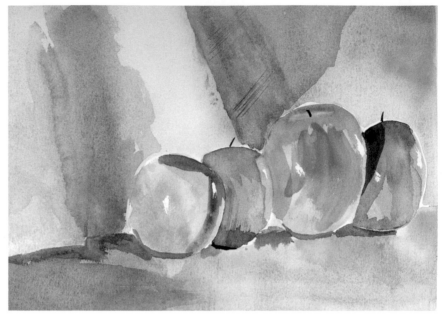

Jonathan Drury, student work, 10″ × 14″ (25 × 36 cm)

Elizabeth Jenks has utilized only cool colors in her painting. Blue-greens, blue-violets, and blue-grays are densely layered in active, transparent strokes, giving volume not only to the pitcher, but also to the background drapery. With all these cool colors, the paper-white conveys a warm light.

Elizabeth Jenks, student work,
15″ × 10″ (38 × 25 cm)

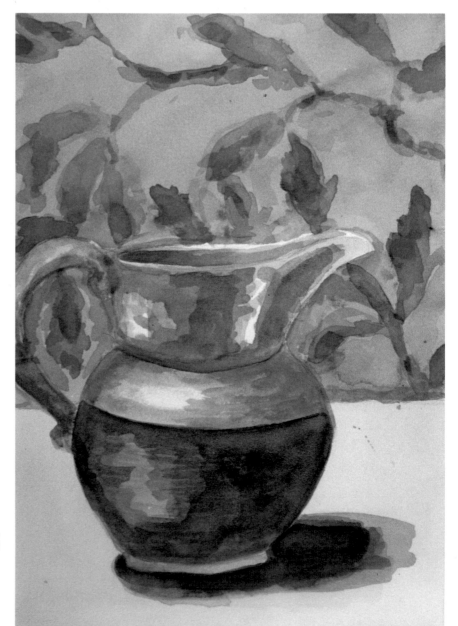

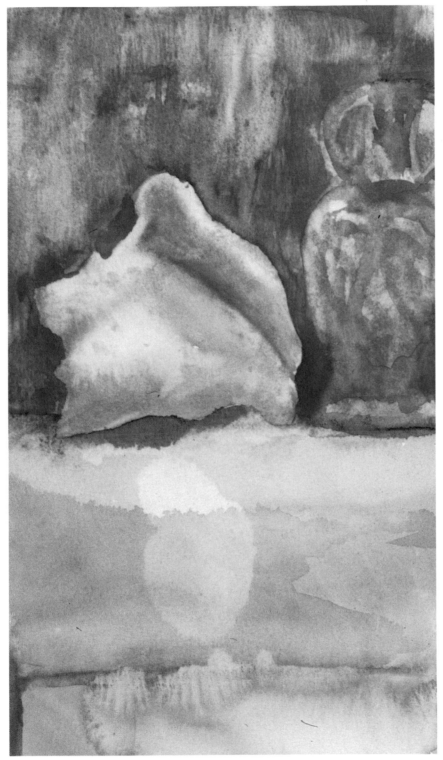

Alice Verberne has patterned a warm yellow into a field of beautifully textured, delicately cool colors. The largest yellow area leads the eye into the cool space, while the smaller yellow areas move the eye up the painting. Although the temperature extremes are great—blue to yellow—there is still a quiet subtlety in the overall color, due to the textural way Alice has applied her paint. At times she let very wet paint bloom at the edges; she also blotted wet paint with tissue. Notice how the color assumes a different personality with different applications.

Alice Verberne, student work, 13½″ × 8″ (34 × 20 cm)

DAY 5
From Value to Color to Light

A strong value organization increases the impact of a painting. One way of achieving this is by observing some basic value systems found in nature. Although the emphasis here is on value, you'll soon discover that the use of color is implicit. And by considering color as an equal partner to value, you'll arrive at an effective representation of light.

Every color, of course, has a value: it is light or dark. Yet color also has a light of its own, which is not the result of value. This light is connected to the color's chroma, or saturation of hue—its intensity. The aim is to merge chroma with the power of value to re-create the light of nature in paint on paper.

To understand all this, we'll work with three basic value systems.

Normal Value Range. In this system the values range from the white of the paper as the lightest value, through the middle values, to the darkest dark you can make. Most of the values are clustered around the middle, with extreme lights and darks used primarily as accents.

High-Key Value Range. In this system the range is restricted. The white paper is still the lightest light, but the darkest dark is now the middle value of the normal range.

Low-Key Value Range. Here the middle value of the normal range is the lightest light. All the other values are darker, moving toward the darkest dark you can make.

To explore these systems, assemble a simple still life with two or three objects. Light it strongly from the right or left. You may want to add a piece of crumpled drapery for interest.

Make three small paintings of the setup. Begin with the normal value range; then do a high-key and a low-key painting based on this. When you're finished, compare all three paintings. Does each painting define a distinct value system?

Because the values are restricted in the high- and low-key systems, there's less resolution of form. Dramatic contrasts are also greatly reduced. The temptation is to add some values outside the system to create excitement. Although you may do this occasionally, don't introduce too many other values. Instead, vary your color as much as possible, within the narrow value range, to enliven your painting.

A final tip: I'm sure you've observed that watercolor dries lighter than it appears when wet. Keep this in mind when painting your darks. Also remember that the darkest dark does not have to be mixed on the palette. You can build your darks with several transparent layers.

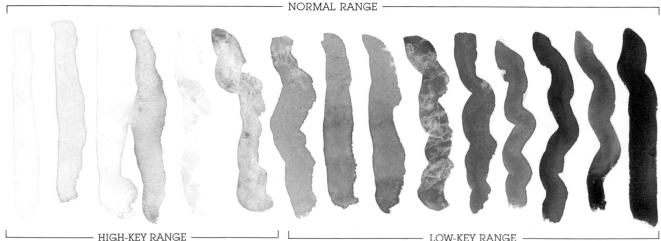

NORMAL RANGE

HIGH-KEY RANGE

LOW-KEY RANGE

Taken as a whole, these strips of color represent the normal value range in the still life I used for my paintings here. You can also see the high- and low-key ranges. It's a good idea to quickly make a similar chart yourself to get a feel for controlling the values of various colors before you render objects with them.

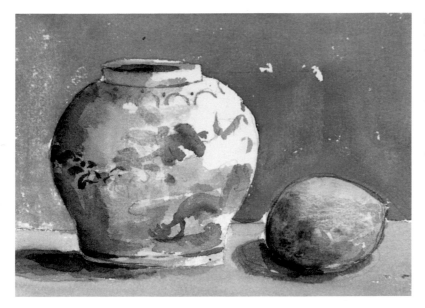

Normal Value Range. *The lightest lights—formed by the white paper—appear as highlights on the vase and as random flecks of light in the background. The darkest darks suggest areas of little or no light—the inner rim of the vase and the point where the objects sit on the ground plane. In between these extremes, there are various light, dark, and middle values.*

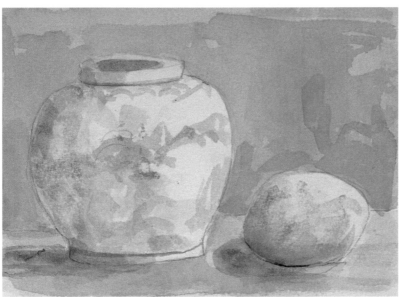

High-Key Value Range. *Here the values are restricted to the light to middle range of the normal value system. Because subtlety reigns in this system, I've expanded the color in certain areas like the shadows under the objects and on the side of the vase to clarify the forms.*

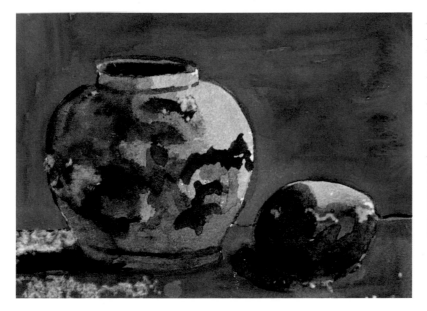

Low-Key Value Range. *This example has been pushed down into the lower value register, from the middle to dark end of the normal range. Notice how I've accentuated the contrast between the reds, greens, and blues to help define the forms. Also notice how, even within this narrow range, there's a feeling of drama to the lights and darks. Experiment on your own with different mixtures and with applying layers of color to improve your skills in creating clear, expressive darks. All too often students don't go dark enough.*

This splendid little painting by Lori Hahn exhibits the normal value range. The intervals between values are remarkably even as they move from the darks to the paper-white, reinforcing the clarity of space and form.

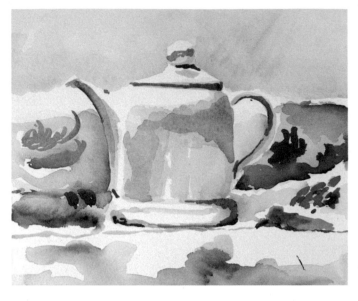

Lori's low-key painting is almost too subtle. While the light is unmistakably low-key, I don't feel that the values are dark enough, and I definitely think that the color could be varied more. Drama and light can still exist in the low register. This is the most difficult part of the problem for most, so follow the instructions to the letter, and push a little further with color and value.

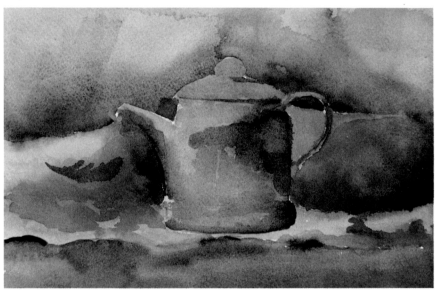

In this high-key version, Lori has again clearly articulated the space with well-placed planes. The bleached light of the high-key system is quite evident.

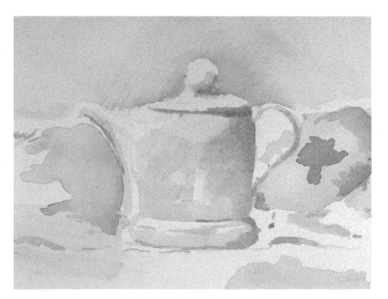

All examples by Lori J. Hahn,
student work, 6″ × 7″
(15 × 18 cm)

46

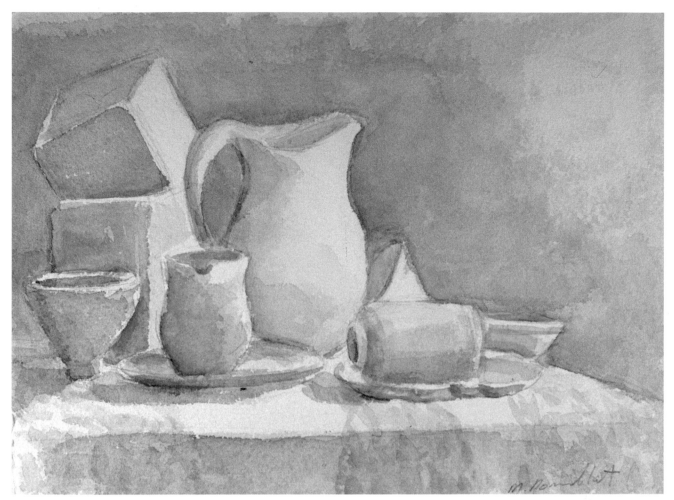

Marcy Rosenblat, *Still Life*, 9½″ × 13″ (24 × 33 cm)

Marcy Rosenblat is an expert in using the sometimes elusive high-key system, and her work beautifully illustrates the quiet, parched light of this system. In this still life, constructed of an array of the geometric solids, she relies on subtle variations of grayed blues, greens, and reds. The red dominates the painting, but the blues and greens gain some emphasis from their isolation. Marcy manages, with well-placed whites, to transform a very close range of values into a seemingly broad one. Remember that bright whites make adjacent values seem darker than they are—allowing you to dredge a lot of mileage out of a limited system.

Regina Tuzzolino excels in working in the high-key range, a system I personally find the most difficult. In part, her success in this landscape stems from the prolific brushwork, which brings an additional visual element to the limited system. Regina has also varied the color, with the sky moving from blue to purple and the ground from green to yellow. Notice how the triangular cloud is turned over and repeated down into the landscape. This strong compositional device forms yet another loud voice in the relatively quiet domain of high-key color.

Regina Tuzzolino, student work, 15″ × 10″ (38 × 25 cm)

Colleen Tully, student work, 14" × 19" (36 × 48 cm)

Colleen Tully's abstract painting beautifully illustrates a low-key range of color. Although the colors are dark, the relationships and contrasts are intense. Are the two glowing verticals in the dark field or behind the dark field? When a painting promotes this kind of interrogation, some form or idea is operating on more than one level, playing more than one role. There is a sense of mystery and intriguing ambiguity. Here the dark, warm smears of yellow and orange speak to me of a ritual fire burning in some distant night or of the evening's sun igniting the doors of a darkened room.

DAY 6
Washes

Most of the time I use the word "wash" to describe a lot of water and a little pigment sloshed onto the painting in the early stages, usually loosely defining large shapes. That's essentially what a wash is, but today we'll look more closely at four basic washes: flat, graded, wet-in-wet, and irregular. These washes can have specific uses—you might, for example, use a graded wash to indicate the sky plane, making it lighter as it approaches the horizon. Or you can use a wash as an unpremeditated underpainting.

I find that painting into color other than white offers alternative ways of constructing light through color, as well as new color variations. Remember that watercolor is a transparent medium. Painting on an orange, a blue, or a gray ground will drastically alter the colors you apply, but it can also unify them with a common constituent color.

How do you apply a wash? To prepare, take a wash cup, saucer, or similar container. Mix pigment with enough water to cover your paper. Go ahead and mix too much. Finding yourself short is a disaster. If you're not using a block, attach your paper to a board or another rigid surface. Now try each kind of wash.

Flat Wash. The goal is to produce a flat surface of color. You have probably already tried to achieve this and more than likely failed. Continuous brushing over an area will flatten oil or acrylic paint, but watercolor behaves differently. The more you pass over an area, the more unwanted blurs, spots, and runs occur. The proper technique, however, is simple; it's based on gravity. Follow the directions carefully and you'll have no problems.

In a well, mix what you feel is enough color and water to cover the sheet you're working on. Be careful not to make too dark a value. This wash will serve as an underpainting. Although you want the color to infiltrate, you don't want the painting to become too nocturnal. A medium-light value will suffice. Test it to be sure.

Set your board or block on a slant. I raise the top edge about one-and-one-half to two inches off the top of the table. Load your one-inch flat brush with paint and make a pass horizontally across the top of the paper. The paint will move downward, with a bead forming at the bottom of the stroke. Load the brush again, and make the next pass a little down the page, in the opposite direction, slightly overlapping the first. It's important to pick up the bead on each pass. Don't waste time; a line can form. It's also important to reverse the direction of the stroke with each pass. This will prevent a buildup of darker pigment on one side of the page. Repeat the process until the paper is covered. Squeeze your brush dry and use it like a sponge to collect the excess wash that has collected at the bottom of your paper.

Fine papers contain rabbit-skin glue as a binding medium. This glue may affect your wash by resisting the pigment, resulting in little spots of white randomly dispersed over the paper. Do not go back in to remove them. I'm always thrilled to have these sparkling "errors" in my wash. They are yet another example of the many unexpected happenings in watercolor that foil attempts at "perfect" technique. (Thank heaven!) You can, however, soak and stretch the paper for fifteen minutes to remove the size, facilitate flow, and prevent the flecks of white.

Graded Wash. This wash should be graded from dark to light. Mix a darker value than in the flat wash. You'll need only enough for one pass. Make the pass across the top of the sheet, clean the brush, and continue the process, as in the flat wash technique, but use clean water for each pass instead of color. You'll be dragging down decreasing amounts of color each time, thus grading the value. Handle the brush just as you did in the flat wash, slightly overlapping each pass, picking up the bead.

Wet-in-Wet Wash. This wash takes advantage of some of the indeterminable qualities of watercolor. Wet the paper thoroughly with a sponge dipped in clean water. Proceed with the technique for the basic flat wash; then immediately go back in with random strokes of darker color, and let the pigment run wherever it wants. Do not wait too long after applying the basic wash, as hard, sharp shapes will form.

Flat Wash

Graded Wash

Wet-in-Wet Wash

Irregular Wash

Irregular Wash. This is my favorite, as it produces very irregular and often stunning effects. Flow clear water over the entire paper surface. While the paper is very wet, drop in dark pigment on top. Pick up one corner of the sheet and let the color flow as much as you wish, in any direction. Lay the paper down flat to stop the action. Should you want to blend some, or all, of the streaks together, change the angle of the paper.

Painting Ideas. With all of these washes, you can lift out shapes with tissue while the wash is still wet or scrub lighter values out of the dry wash with a hard bristle brush or eraser. After the wash is completely dry, you can superimpose another color using the same or a different technique. You might, for example, paint a flat blue wash over a graded pink wash or a graded yellow over a wet-in-wet blue wash.

Use each of the four wash types as a random beginning for a painting. Do not worry if the color or texture does not seem to fit the subject. It's usually better if it doesn't. Vary your subject matter from painting to painting. Remember that the paper-white has been completely removed or at least significantly diminished. The lightest light is now the underpainting, so push your values to prevent too close a range. Observe carefully the effects of the dominant underpainting color, as well as of texture and gradation.

For my painting outings in Italy, I am always prepared not only with an assortment of pre-cut sheets of paper, but also with several pre-painted washes. I make these ahead of time in my room, so they're dry and ready to paint on. I vary the colors and kinds of washes at random, with no specific plan in mind.

Here I chose a flat, pink wash to paint the dome of a cathedral in Florence. It was a fiery, hot afternoon, so the warm underpainting seemed appropriate. I was pleased with the way the pink enhanced the light on the dome itself and warmed up the blue sky and blue-green hill in the background.

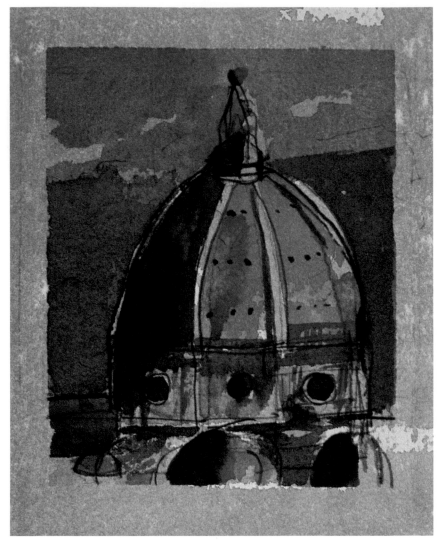

Michael Crespo, *Il Duomo*, 5″ × 4″ (13 × 10 cm)

In this painting Julyn Duke successfully overcomes an extremely dominant underpainting. A graded red-orange wash was painted over a flat, yellow one, resulting in a fiery tone, more likely to suggest an abstraction than a still life. Overpainting can never quell such a pervasive ground, especially in transparent media. But Julyn doesn't attempt to neutralize it; instead, she enhances it. She has forcefully modeled the space with gray values. A cool gray seems to surface at the top of the painting, where the color is not as strong due to the gradation of the wash. Julyn has reinforced the orange fruit with an even more brilliant orange, pulling it ahead of the pack a little. Overall, this painting works on value modulations permeated by the paramount breath of heat—a still life ablaze.

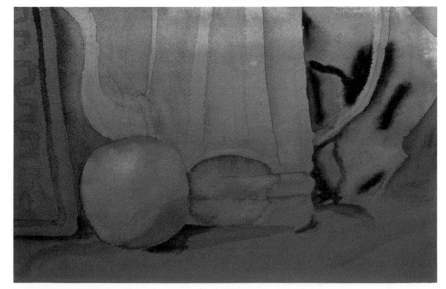

Julyn Duke, student work, 7″ × 11″ (18 × 28 cm)

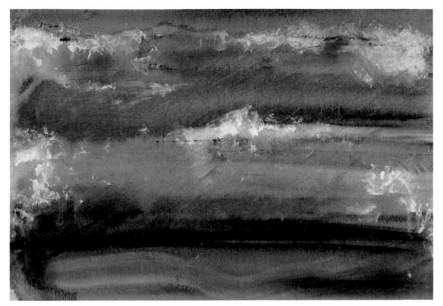

Joel West, student work, 9″ × 13″ (23 × 33 cm)

Joel West set out to make a routine wet-in-wet wash. As he worked, he began to see images of a nocturnal sea in the wet meanderings of the wash. With a crumpled tissue, he pulled shapes of breaking waves out, and the painting was finished. A simple technique produced a complicated mass of values, which, with slight modification, became a lovely, effortless, evocative statement. Of course Joel had to be paying attention. The lesson to learn—always be looking for a painting.

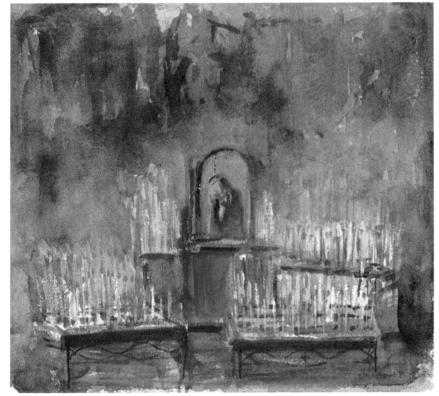

Michael Crespo, *Altar to the Virgin*, 11½″ × 15″ (29 × 38 cm)

Two irregular washes were the basis for this smoke-filled painting. In Florence one morning, my wife and I were caught in a sudden, violent storm while across the river Arno. We sought refuge in the church of Santo Spirito, where the only light was from an occasional spark of lightning and hundreds of candles burning in praise of the Virgin Mary. Later that afternoon, in my room, I sought to paint the indelible impression the morning had left in my eyes. First, I made a rough sketch and applied some masking solution to keep the candles paper-white. Next I laid in a light pink, irregular wash, agitating the paper furiously while the pigment flowed on the wet surface. I allowed this to dry thoroughly before wetting the paper again and repeating the gyrations, this time with Payne's gray. When this was dry, I removed the masking solution and painted the altar into the billowing atmosphere the washes had established.

After doing an initial drawing, Cheryl Trask laid in the wet-in-wet background wash. She controlled the wash, ending it along the top edge of the pitcher and drapery, and blotting any overruns with a tissue. When the wash dried, she painted the rest of the still life. In the finished work, the streaked, undulating wash serves as a fine rendering of drapery folds, as well as a delightful counterpoint to the strictly articulated objects.

Cheryl Trask, student work, 11" × 15" (30 × 38 cm)

This painting involved an elaborate series of washes. First I painted the bird, the water he's walking in, and the leaves on the bank. Then, after everything had dried completely, I added a flat, brown madder wash; which I altered with some blotting. This wash was painted over the bird, plants, and other areas. Next I applied a flat wash of cerulean blue, which I varied by using a mixture with a little more pigment for some of the strokes. I also allowed some of the strokes to set a bit before continuing. This resulted in the streaks in the sky. Finally, I dragged down a graded wash of indigo, which is particularly heavy at the top.

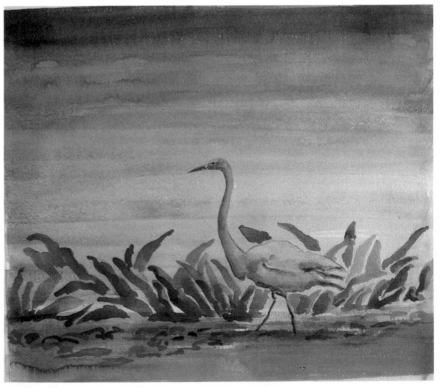

Michael Crespo, *Great Egret*, 14" × 16" (36 × 41 cm)

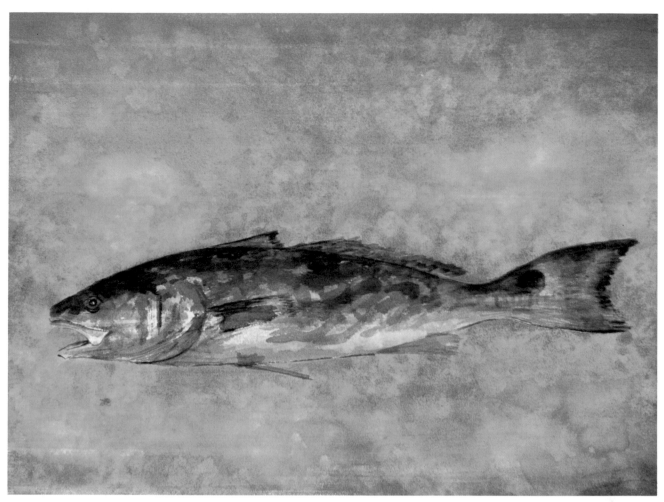

Michael Crespo, *Redfish Feeding*, 21" × 29" (53 × 74 cm)

The image of the redfish is sandwiched between two washes in this full-sheet painting. First I laid in a standard wet-in-wet wash of light yellow-green, which produced large, horizontal irregularities. I then painted the fish. When he was dry, I quickly, with a large utility wash brush, laid in a dark blue-green wash over everything, including the fish. While this was still wet, but drying fast, I stippled, using wads of tissue paper with blinding speed and both hands. I began with the fish, so as not to lose the warm and light tones, and worked out to the edges. The result is a heavily mottled surface, which I love to look at (and love even more to paint).

DAY 7
Wet-in-Wet

Beginners often encounter problems when working on wet paper. But you can turn this liability into an asset and use the wet-in-wet technique to obtain some stunning effects.

One of the most exciting aspects of watercolor is the way the paint flows on the paper. When you work wet-in-wet and let the water follow its own course, you can enhance the ephemeral and fleeting quality of watercolor. This technique will also encourage you to think differently about composition. You can't rely on the usual defining brushstrokes or hard edges. Instead, you must compensate for the soft edges and slightly blurred focus with stronger value and hue contrasts. You have to apply the paint boldly to get interesting results.

For today's exercise, assemble any objects of your choosing, but don't let the setup become too simple. I suggest a vase of flowers with an assortment of fruit at its base and a brightly patterned drape behind.

From this setup, make three paintings, using slightly different techniques:

Direct Wet-in-Wet Painting. For this approach, wet your paper thoroughly in a sink. Shake off the excess water and set the paper down on a board. Don't do any preliminary drawing; just start blocking in the composition with paint. Remember to use strong color. And pay attention to what's happening as you paint. Working wet-in-wet implies a certain freedom from control, but you must learn how to use what happens to your advantage.

If the paper begins to dry, either drop more water on it or wet the board beneath the paper. A nonporous surface helps to maintain wetness. I use Masonite covered with formica—the kind used in bathroom construction—which is available from any building supplier. In any event, work fast.

For this exercise, if you want some linear structuring, use the handle of your brush or some similar point to etch into the wet paper. The pigment will then accumulate in the scratches, forming dark lines of color.

Wet-in-Wet with Line. Now take a different approach. First make a pencil drawing of your setup—before you wet the paper. Then proceed as before, only this time base your flow of paint on the structural line drawing. Don't, however, let the line restrict your paint flow. See if you can be just as free when you use line as when you paint directly.

Wet-in-Wet within Shapes. On dry paper, paint intricate shapes with clean water only. Immediately drop in a variety of colors. The edges you have defined will hold, but the colors will run rampant within the wet shape. This is a very useful technique, which you can use either for a whole painting or part of it. The shape is controlled, but within its edges, the pigment flows freely and spontaneously.

Direct Wet-in-Wet Painting

Ellen Ellis, student work, 12″ × 11″ (30 × 28 cm)

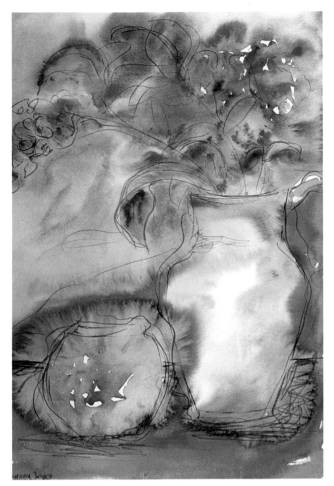

Wet-in-Wet with Line

Elizabeth Jenks, student work, 15″ × 10″ (38 × 25 cm)

Now let's apply these three different wet-in-wet approaches to some of the problems we've encountered in earlier lessons. You may wish to change setups for this part of the exercise. Indeed, at one point you'll have to, because I'm going to ask you to attack a landscape.

Variation 1. Review what you learned on Days 4 and 5 about color temperature and value. Then, using the first technique—working wet-in-wet directly—do two paintings. In one make warm, high-key colors dominant; in the other use cool colors in a low key. With all the water saturating the paper, it should be easy to keep your colors light in value for the high-key painting. For the low-key painting, however, you'll need more potent mixtures to get dark, brooding values.

Variation 2. On Day 2 you mixed various grays from the primaries and then used these grays to create dramatic lighting in a painting. Repeat that exercise, working with the second wet-in-wet technique, the one incorporating line. On Day 2 it was imperative to let each stage of your practice painting dry before going on to the next stage. Now, however, you must keep the painting wet at all times. I recommend that you mix all the grays before you begin painting. Don't try too hard to achieve neutral colors; let traces of the primaries tinge your grays to give the painting more color.

Variation 3. The third technique—painting wet-in-wet within shapes—is a natural to use to review the lesson on shape and color composition (Day 3). Choose a landscape setting and fill your paper with shapes based on what you see. Draw these shapes in pencil—in this way slightly varying the third technique. Now return to your studio to do the actual painting, working wet-in-wet within the shapes you've drawn. Use a lot of color, but do not let the shapes run together. Instead, leave little lines of paper-white between them, or allow one shape to dry before painting an adjacent one.

Wet-in-Wet within Shapes

Regina Tuzzolino, student work, 10″ × 7½″ (25 × 19 cm)

Variation 1 (Hot). *This high-key warm painting, based on a setup of summer squash and a green apple, was done by working wet-in-wet directly.*

Variation 1 (Cool). *The same technique—working wet-in-wet directly—was used for a low-key, cool painting of three plums on a blue-green drape.*

Variation 2. *The exercise on the "movement of grays" (Day 2) was repeated using wet-in-wet technique with line. Although the wet-in-wet process allowed the grays to merge more, the dramatic effect of light was still achieved. I'm actually more partial to the muddled, less defined forms.*

Variation 3. *Following the third technique, a variety of colors were dropped into the same wet shape. The mingling of these colors gave this painting an undulating space. You might try repeating the process in the same shape, letting the initial mingling dry and then applying the clear water and pigments a second time.*

Elizabeth Jenks, student work, 15″ × 10″ (38 × 25 cm)

In Elizabeth Jenks's explosive version of the standard wet-in-wet tech-nique, any semblance of the still life is drowned in the deep puddles of water that produced the wild dispersal of color and form. Working with such uncontrollable amounts of water and waiting in anxious glee for the unpremeditated results may seem almost too much fun, reminiscent of making "spin-art" paintings at a carnival. Don't feel guilty, indulge yourself once in a while. Run out to the limits and back. Elizabeth did!

Christy Brandenberg, student work, 12″ × 8″ (31 × 20 cm)

Alice Verberne, student work, 20″ × 15″ (51 × 38 cm)

How wet to make the paper is up to you. Here Christy Brandenberg worked wet-in-wet into defined shapes, but with a slightly drier surface than in the other examples. Consequently the paint does not mingle as drastically. The wetness varies in her painting— obviously, the blue ground plane was wetter than the two flowers. In a few places, Christy has gone into dry paper to establish a focus—a practice you should always consider at the end of a wet-in-wet painting. Never substitute attempts to remain a "wet purist" for a necessary solution to the painting. The same applies to any other technique. Vision brings technique. Rarely does technique bring vision.

Also notice Christy's effective use of white. The large mass at the top cascades down in rivulets, defining the edges of everything.

Alice Verberne has successfully combined two techniques in this floral study. First, she wet a large area of the paper, from the bottom left up and across to the top right. Following standard wet-in-wet practice, she dropped in color. When this was dry, she developed the right side, working wet-in-wet within shapes. In the painting these appear as relatively sharp-edged flower shapes and stems. (You can also see a few in the top left area of the bouquet.) This technique proved an excellent way of establishing focal points.

Alice's color choices are also effective. She has based the painting on the complementary colors red and green, with the reds ranging from red-violet through red and orange to yellow and the greens going from blue-green to yellow-green. The result is an affable blend of warm and cool temperatures—a perfect day, you might say.

Deana Houston first laid in the warm, brownish orange over the entire ground plane and apple shapes. In this instance the paper was not soaked first; rather, the initial wash served as the base on which to proceed. Into the wet wash Deana maneuvered a cool, blue-green gray, which became the shadow color. She was careful to leave some white shapes on the apples as highlights. Next she added darker blue-greens and oranges to give the apples volume. Finally, when everything was nearly completely dry, she painted the dark stems and shapes at their bases.

Keep in mind that, unless you continue to dampen a wet-in-wet painting, the drying process continues, making your brushstrokes progressively more defined, from early blurs to sharp accents. This technique can be very desirable as it layers different focuses in the composition, and any layering creates a sense of space. Deana has made subtle use of this effect here.

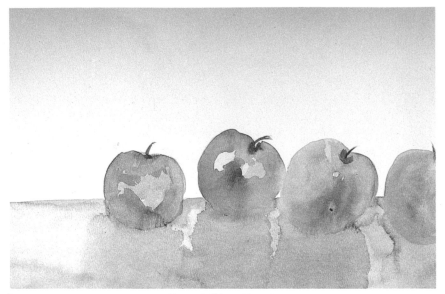

Deana Houston, student work, 12" × 16 (30 × 41 cm)

I have sat across the river from Florence a hundred times and questioned, with my brush, the color, form, and magic of the skyline that marks this most exquisite of cities. I began this particular painting with a flat gray wash. After it dried, I sketched what interested me out of the thousand possibilities the panorama offered. I then painted the broad, blue plane that denotes the mountain range behind the city. When this dried, I carefully soaked the entire painting in clear water, shook it off a bit, and quickly painted the rest. When finished, and when the paper was almost dry, I spotted the small dark windows here and there.

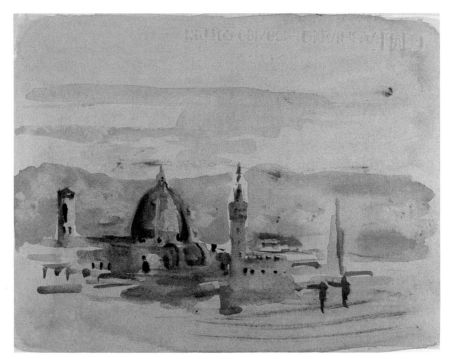

Michael Crespo, *View of Florence*, 11" × 14½" (28 × 37 cm)

Michael Crespo, *Villa Downriver*, 5½" × 7½" (14 × 19 cm)

This painting illustrates the enigmatic air that the wet-in-wet techniques can impart. I worked this painting a long time, letting it almost dry, then wetting it again, and smearing the edges of almost everything that was in focus. Finally I stopped, disappointed with what seemed altogether vague, nothing but a fuzzy, red roof line and two dark poplars. I stuffed the painting in my bag and sought out a favorite cafe.

Days later the picture surfaced out of a stack of sketches, and I was beside myself with the joy of accomplishment. My little, senseless blur had become a wonderfully faint disclosure of the mystery that permeates the Tuscan landscape. The simple passage of time can be a great studio assistant. If you can't solve a painting, put it out of view for a few days. When you confront it again, your eye will be more objective, quickly discerning its success or failure.

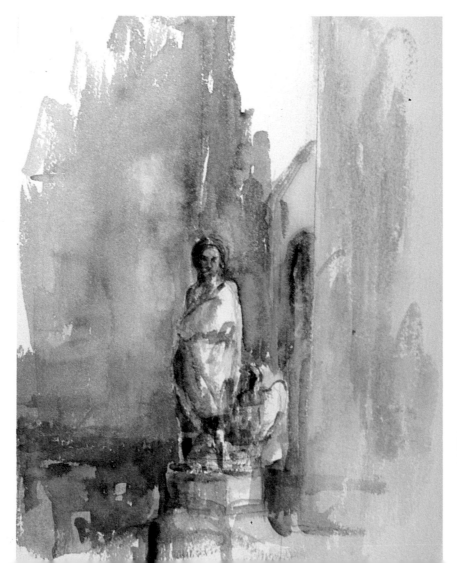

I don't particularly care for this statue itself, but I painted it in homage to the great poet. I started this painting on a very saturated piece of paper, which I allowed to dry in its own time while I painted. With this technique, the later marks tend to speak with more assurance than the early ones. The statue was surrounded by busy architecture, automobiles, motorcycles, bicycles, and people. To suggest all that, I simply slopped in some wet paint. Similarly, I tried to make Dante appear without laboring the entire afternoon on the tedious sculptural ornaments that surrounded his legs. After settling on some sketchy details, I finished the painting by trying to vary the color as much and as subtly as I could.

Michael Crespo, *Monument to Dante, Piazza Santa Croce*, 15" × 11" (38 × 28 cm)

DAY 8
Two-Day Glaze

A well-known oil painting technique is to make a drawing and then develop the forms and light in one color—usually black—with white. The painting is completed in every detail except color. After this underpainting, or *grisaille*, is dry, colors mixed with a transparent medium are glazed over it. The value changes and linear detail are all in the underpainting and are seen through the transparent overlays. Sometimes many colors are glazed over a single form to produce a deep luminosity.

Since watercolor pigments are naturally transparent, you can employ a similar technique.

Work from a relatively busy still life, or choose an interior view. Whatever you decide, make sure that there are a number of color changes. I don't recommend a landscape for this exercise because the tendency is to make everything green, and I want you to use a range of color.

This painting will be made in two days, or with a reasonable amount to drying time between the two stages. I suggest that you take the two days to do it. The first stage will probably take some time. If you work fast, do two paintings.

Begin with a light pencil drawing. Mix a neutral gray from alizarin crimson and phthalo

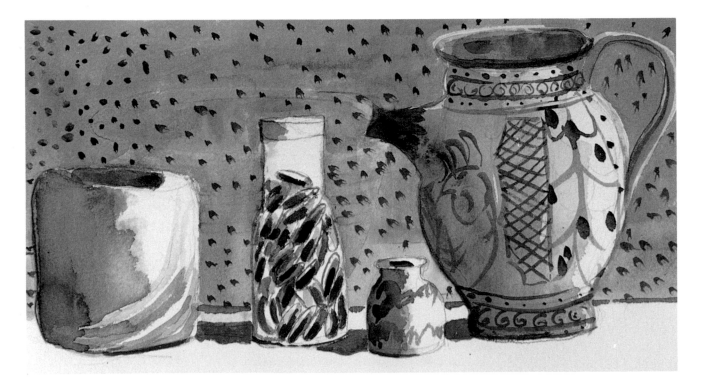

Monochromatic Underpainting. *The spotted drapery, the ornate pitcher, and the repetitive chilies in the jar gave a decorative emphasis to this subject. I modeled both vases and the pitcher, however, to suggest their volume. At this point I did not really know what to do with the chili jar, so I left it flat, marking the peppers a little. I laid in a slightly wet wash in the background, left ample paper-white on the objects and ground plane to signal the strong light from the right, and punctuated the entire composition with some very opaque darks.*

green. These two colors have great staining power, which is desirable in an underpainting. Other good colors to use in an underpainting are burnt sienna, phthalo blue, lemon yellow, viridian, cobalt blue, rose madder, Winsor red, and violet. The more opaque colors—such as ultramarine blue, cadmium red, cadmium yellow, cadmium orange, and yellow ochre—tend to mix into the overlays. I would avoid them in an underpainting. If you have to use one, don't apply it too thickly and use a light touch for the overpainting to avoid agitating the pigments underneath.

Develop this painting with an eye to value and light. Don't hesitate to employ what you have learned about wet-in-wet and other techniques. Complete the painting to the final details. You want a strong value range, so leave some white paper (if in doubt, leave a lot of white). Also make sure you find some full-strength darks. I cannot stress the importance of this enough. In the next stage you will be glazing over color,

which will lessen the crispness of the value, so it must be overstated.

When finished, allow the underpainting to dry until the next day. Time away from a painting sometimes brings a fresher, more open-minded approach. The next day begin by painting color over the value painting. Traditionally this overpainting was flat, but it can be exciting to vary your technique. Choose a value slightly lighter than middle. If you are hesitant, start with pale values and build them up as you gain confidence. If you established a strong value range in the underpainting, then you will have a dominant structure to build upon. If you did not, add some dark colors as you near completion. Vary your color by using different mixtures. Also try mixing with transparent overlays—painting yellow over a dry blue to make green, for example. Some artists like to leave some of the white paper throughout. It is not necessary to cover all of the underpainting.

Final Version. *After much deliberation, I decided to preserve the lively, airy underpainting by keeping the color light, definitely not overworking it. I played on complementary colors, blue and orange; then dusted in a faint green on the chilies. Although I ended up covering most of the whites, I did leave some small shapes here and there for articulation. As for technique, I kept this one straight and flat, with little invention or variation. I was very pleased with the energy of the grisaille and didn't want to tamper with it too much.*

Monochromatic Underpainting. *This underpainting is less decorative and more atmospheric than the first. I employed a variety of wet-in-wet techniques, seeking a softer, more mysterious rendering. There was as much blotting out with tissue as painting in with brushes. Notice the drips and splatters in the ground plane. On the shells I flicked a script brush to create the broken contour lines. All in all, this underpainting was done more as a continuum than as a description from part to part.*

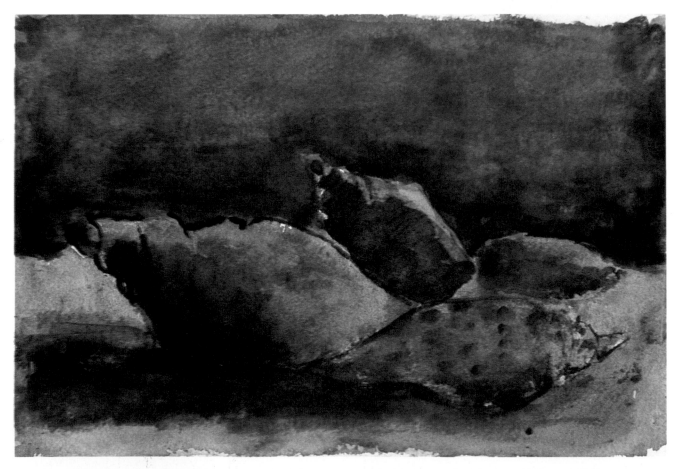

Final Version. *What do you do when you're satisfied with the underpainting and see no reason to go on? I often confront this dilemma, but even then I wonder: what would a little color (or a lot) do? Usually I just can't stand wondering anymore, so I do something. That's what I'd recommend: always do a little something, even if it's just adding some extremely light washes. Try to lead the gray underpainting into slight color variations, perhaps giving some temperature readings. If the underpainting "works," it will be next to impossible to destroy it; if, however, the underpainting is shaky, it's a toss up whether you'll be able to salvage it or not. In any case it's definitely worth the gamble.*

With this example, I was a bit unsure how to proceed with color. I decided that the shadows of the shells should be cool, with warmth surrounding them. To disturb the symmetry of this notion a little, I laid in cool washes on the foreground shell, including it in the shadow temperature. After developing the cool bluish areas, I began to lay in the background, using five or six different warm washes, letting them dry between coats. I also deposited each background wash somewhere in the bottom of the painting, either on the shells or on the ground plane. I simply continued building these washes until I felt that the color saturation and the value modulation were "right."

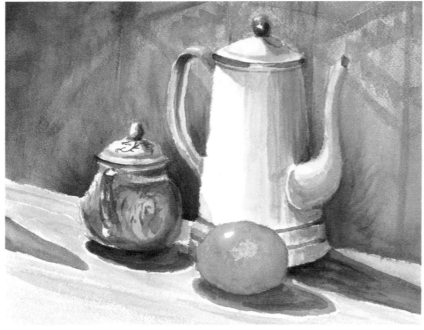

Joe Holmes, student work, 9½" × 12½" (24 × 32 cm)

Joe Holmes's color changes subtly with the value, moving in and out of the shadows. To achieve these delicate nuances, he carefully detailed the underpainting. Look closely at the methodical vertical striping in the coffee pot, which suggests its volume; the gentle stippling in the tangerine; and the decorative handling of the sugar bowl and the wall. Also notice the powerful diagonal design. If you're not careful, diagonal lines can be very fast, moving the eye too quickly across the objects along them. Here, however, the tangerine has enormous strength, both in color and central placement; the whites of the coffee pot glow against the dark surroundings; and the sugar bowl has a complex form. All these devices stop the eye in its race across the diagonal and make it linger on the objects for a time. So there are two opposing concepts, the fast diagonal line and the slow triangle of volumes, both in the same painting, adding an exciting tension to the space.

Also intriguing is the shadow cast into the painting from the left, from an object outside the painting. This shadow serves two important roles. It evokes mystery, making the viewer inquisitive about the unseen object. It also echoes the shape of the coffee pot's shadow, joining in its rhythm.

Madeline Terrell's underpainting was very detailed, especially with regard to textures. In the finished version here, she explains with her brush how the shell, ground plane, background, and vase would all feel different in our hands. There is also a forceful value range, with deep darks and key white-paper highlights. Remember that the value usually diminishes somewhat when you glaze over it.

Madeline's color is limited, but effective. She has used the "color on a gray field" system: the pinks and blues at the top and dark blue and red in the center are all contained in a field of warm grays. Also effective is the placement of the commanding red in the compositional center.

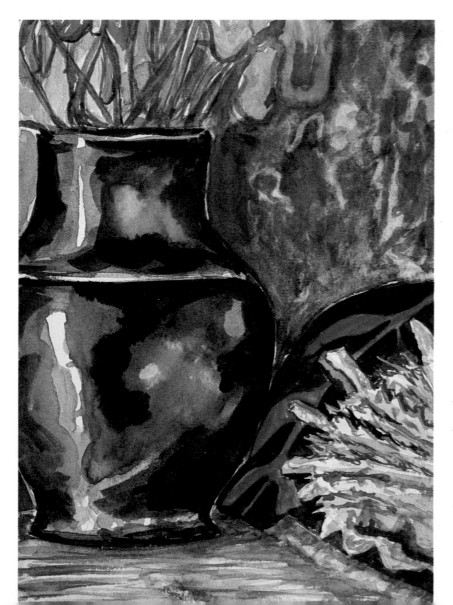

Madeline Terrell, student work, 9½" × 6½" (24 × 17 cm)

67

DAY 9
Within and Without

A volume can be constructed from within its boundaries, or it can exist because of its surroundings. Look at the drawings of Michelangelo to learn about this. There are drawings of single figures on blank white fields. Within the defined edges of the figure, he has densely packed rippling waves of musculature. This exaggerated activity, like a wound spring, pushes against the contour lines and the picture plane, rendering the illusion of mass and volume. The energy of the form is within. There are other works where the figures are only lightly, if at all, touched with drawing, but the space surrounding them is teeming with activity. These figures seem to buckle out of the paper, much in the way a volume is formed if you press your hands into wet clay, forcing a shape to emerge between them. The energy is without.

Also look at the still life drawings of Giorgio Morandi, which are distinguished by obsessive crosshatchings of ink lines. In some, the crosshatchings are concentrated on the objects. In others, they comprise the field surrounding the objects. Then study the watercolors of Paul Cézanne. I recall a skull almost entirely void of markings, but around its perimeter is a maze of multicolored brushmarks. In another work there is

a bottle heavy and dark from layers of transparent planes.

Working within or without is not just a technique—it can play an important role in composition. When you use both methods in the same painting, a dichotomy is produced, forcing a spatial irony. Use this as a compositional cornerstone on which to build.

To set up a dichotomy, choose two objects: one that will promote internal painting (for example, an object with a lot of texture or multiple facets) and one that is simpler, perhaps with a smooth, expansive surface. The challenge is to paint one object from within and one from without, and yet keep the painting as a whole coherent. For one object, then, devote the majority of your marks to its interior. For the other, keep as much of your work as possible in its surrounding environment. But don't make this an absolute; you need transitions from one method to the other. While constructing the object from without, make some definitions within as well, and vice versa.

I suggested that you use two objects of different textures. It's probably easiest to begin by painting the obvious. But it can be interesting to reverse this and to paint the heavily textured object from without.

This drawing bluntly shows the basic concept discussed here. The circle on the left is transformed into a sphere by the markings inside its contour, while the one on the right gains volume through the activity outside its contour. There is some light modeling within the right form, but the predominant force is the surrounding crosshatching. Similarly, there is a trace of subordinate activity surrounding the left sphere. Note the disjunction in space from the contradicting techniques as they lie side by side.

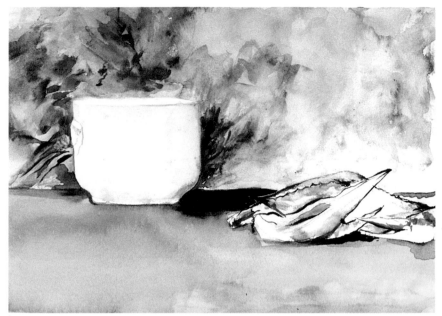

This still life consisted of a preserved crab and a white ceramic sugar bowl. Mylene Amar chose the obvious route: painting the crab from within and the bowl from without. She has described the intricate lines of the crab's armor in fair detail, while marking the internal shape of the bowl with only faint planes of barely perceptible color. Behind the bowl, the colors and markings are intense, but notice how they gradually fade as they move away, toward the crab. To develop this rear plane, Mylene first applied faint colors wet-in-wet to stage the atmospheric lack of focus. As this dried, she built up the area surrounding the bowl in both focus and color.

Mylene Amar, student work, 10″ × 14″ (25 × 36 cm)

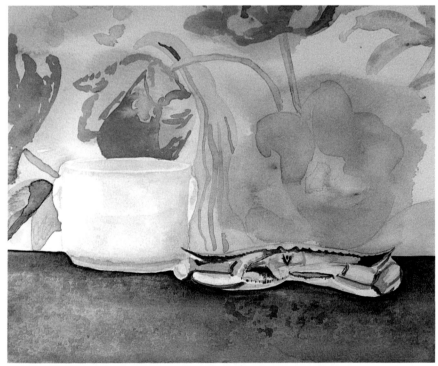

In another approach to the same problem, made from the same still life, the concept is treated in much subtler fashion. Marcy Blanchard has painted the floral background in broad, lilting shapes, unlike Mylene's textural treatment. The impact of the background on the softly bulging bowl is of a different nature. Instead of forming an explosive edge, the broad red and green shapes gently nudge the volume into existence. There is some linear description of the crab, but Marcy has concentrated her efforts on modeling the planes of the claws and shell in delicate grays and oranges. Although this painting may be less dramatic than Mylene's, I consider it a successful solution to the problem.

Marcy Blanchard, student work, 9″ × 11″ (23 × 28 cm)

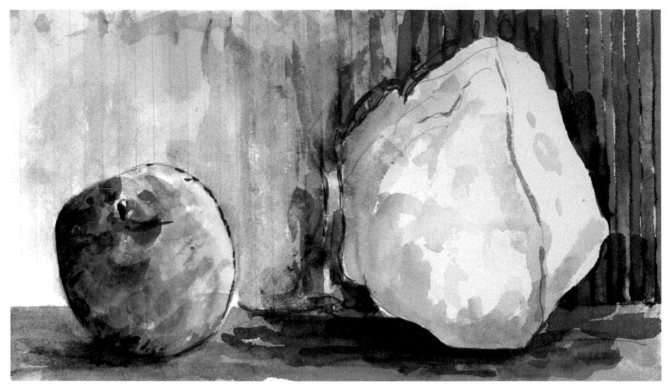

Michael Crespo, *Still Life with Orange and Cabbage*, 6" × 11" (15 × 28 cm)

I have always loved to play with two objects in a painting—the conversational potential between two voices is simpler and thus more easily observed. Here I reversed the obvious ploy in rendering the relatively smooth orange and the striated cabbage wedge. For the orange, I invented a multilayered surface of abbreviated brushstrokes, while I reduced the cabbage to a simple white rock, faintly described. In line with this, I intensified the striped background around the cabbage shape, but let it fade as it moved behind the orange. I also made the ground plane more agitated under the cabbage. As a final embellishment, I inscribed some pencil lines in the pale background behind the orange so as not to lose the effect of the stripes completely and to make the transition across the back less abrupt. Remember that transitional zones in the background and ground planes are key to successfully combining these two contrasting techniques within a single painting.

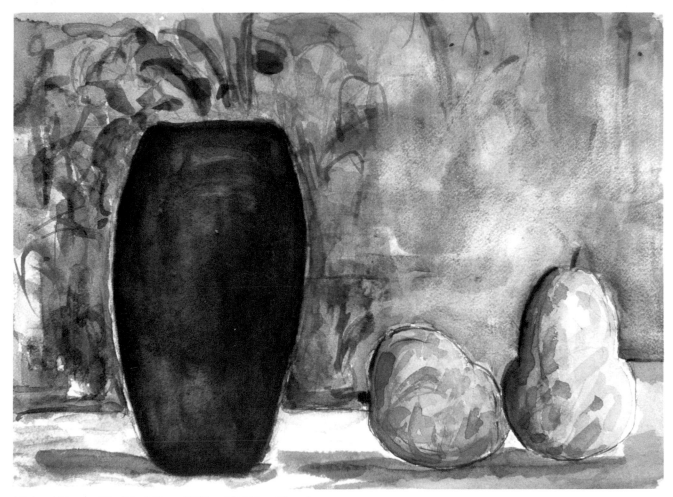

Michael Crespo, *The Black Vase*, 10½″ × 14″ (27 × 36 cm)

I must confess that I did not begin this painting with the idea of within and without, but later rescued the failing painting with the concept. Initially my intention was to show off the stark black vase and yellow pears against an intricately decorated background. All went according to plan, except the painting never did gel. I simply overworked it.

A month later, as I went through a stack of paintings deciding which to toss and which to attempt to save, this one flashed a message in giant red letters: "Practice what you preach—within/without!" There's never anything to lose, so I began the transformation by scrubbing out the busy background surrounding the pears (which I had chosen as the likely candidates for inside painting). I then scattered small planes across the pears to substantiate their volume. I also flattened the vase some by scrubbing in an additional wash of indigo, which is the base color of its blackness. The background here remained the same, as it was already quite active. The concept of within and without may have come in the "back door," but it saved this piece of paper from the trashcan.

DAY 10
Texture

So far your paintings have been based on perception. You began by looking at something. But during the painting process you had to work with concepts to translate three-dimensional objects into a two-dimensional composition. To suggest volume, for example, you modeled light to dark. Or recall your work with shapes and color from Day 3.

Now let's make a totally conceptual painting, one based on the act of painting itself rather than direct observation of a subject. As a motif, we'll explore different ways of producing texture in watercolor:

- *Tissue, paper towels, or napkins.* Use these materials to lift paint. Each leaves a distinct pattern, varying infinitely with crumpling.
- *Stampings.* Press anything that you can apply paint to onto watercolor paper: leaves, wine corks, and sticks, for example.
- *Sponges and brushes.* Lift wet paint off the paper with a sponge or a brush to create soft patterns of light. Also use the sponge as a paint applicator.
- *Brayer.* Apply paint, perhaps in several colors, to a brayer (the inking roller used in printmaking). Then roll it on wet or dry paper.
- *Squeegees.* Using matboard scraps or credit cards, drag pigment from one area of a wet painting to another, leaving interesting tracks, which vary with the paper texture.
- *Brush handle.* With the handle of your brush, scar or distress the paper surface, either just before painting or while the area is still wet, producing dark lines and marks.
- *Palette knife.* With a palette knife, dab or drag pure pigment on wet or dry paper. Use the edge to create very thin lines.
- *Toothbrush splatters.* This is classic technique! Scrub a damp toothbrush into pigment; then, with your thumb, pull the bristles back and splatter color on the painting. You can mask areas with torn or cut paper to control shapes.
- *Crayon resist.* First draw with white or colored crayons on the paper. The wax will resist any watercolor painted over it, leaving the crayon exposed.
- *Masking solutions.* Use these solutions, available from art-supply stores, to mask areas and build mazes of intricate pattern. Paint the solution directly on white paper or on previously applied color. Usually there's a dye to indicate where the solution is, and it can be easily removed with a rubber-cement pickup.
- *Blooms and water effects.* Touch water into barely damp areas of color. As the paper dries, these waterspots will form patterns. Also explore sprinkling, spraying, dropping, or brushing clean water into already dry color.
- *Salt.* Sprinkle coarse table salt on a moist area of color. Pigment will be absorbed by each grain, leaving texture variations. Dust off the salt with your hand when the painting is dry.
- *Wirebrush and sandpaper.* Try modifying the texture of the paper itself. Before painting, stroke a wire brush in one direction over the surface of the paper. Or lightly rub sandpaper over the surface, so it accepts more paint and becomes darker. Do not use coarse sandpaper unless you want scratches. But, if you want a rough surface, try scratching the paper with a knife or a razor blade; the pigment will then settle into these abrasions.

A word of caution, however: don't get addicted to these textures. In moderation they can be very constructive, but when used in abundance they can make a painting tricky-looking. Today—for this lesson—indulge yourself and see what can be done. But in general, be judicious.

As a way to begin, choose one of the following titles for your painting: "Ocean Grayness," "Red Crush," "Moonlight Sonata," "Dark Winds," or "Sun Scheme." Let the title set the mood, but keep away from recognizable subject matter. Instead, make a painting about texture using a few, many, or all of the textural effects just described. You might even invent some of your own. In addition to texture, play with color, line, shape, and value as the "subject" of your painting.

Lifting out with tissues, paper towels, and napkins.

Colors rolled with a brayer.

Left: shape pulled out with a brush (top) and a natural sponge (bottom). Right: paint applied with a cellulose sponge.

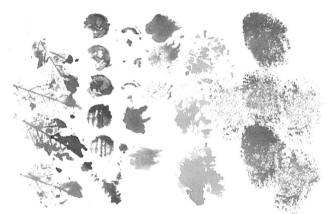

Left to right: stampings with leaves, wine cork, stick, orange peel, crumpled plastic bag, and packing foam.

Paper etched with a brush handle before and after the paint was applied.

Left to right: paint dabbed with a palette knife; paint dragged with a knife; knife worked into wet paint.

73

Paint pulled across the paper with a credit card.

Toothbrush splatters over torn-paper shape.

Crayon resists.

Masking solution applied and sometimes removed between washes.

Waterspots.

Salt sprinkled in wet black wash over green.

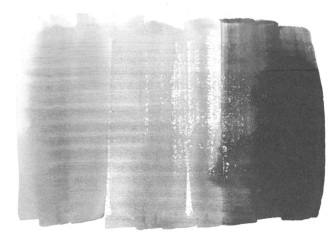

Paper sanded with a horizontal motion before painting.

Paper scraped with a wire brush before painting.

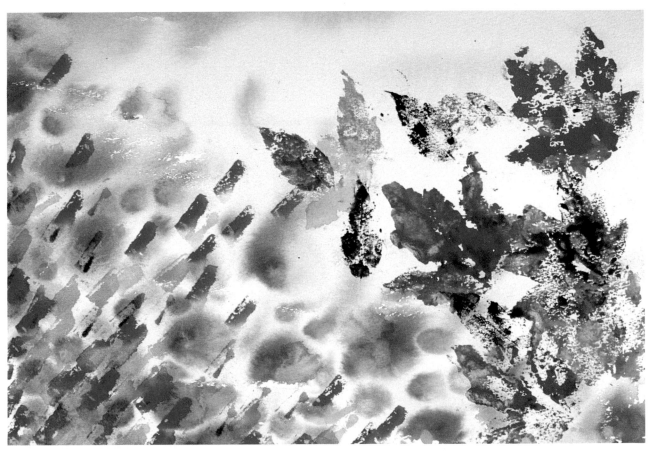

Gloria Jalil, "Sun Scheme" (student work), 9" × 13" (23 × 33 cm)

Gloria Jalil's marks take on the look of bugs, flowers, and butterflies. She set up the background space with wet-in-wet blooms. When these were dry, she made stampings with leaves and a sponge. She has used this dry-on-wet technique very effectively, as there is a great spatial lunge from the hard marks on top to the soft billowing in the distance. I also applaud the wonderful sweep of movement here—up from the bottom left with the sponge marks, across, and down to the bottom right with the leaves.

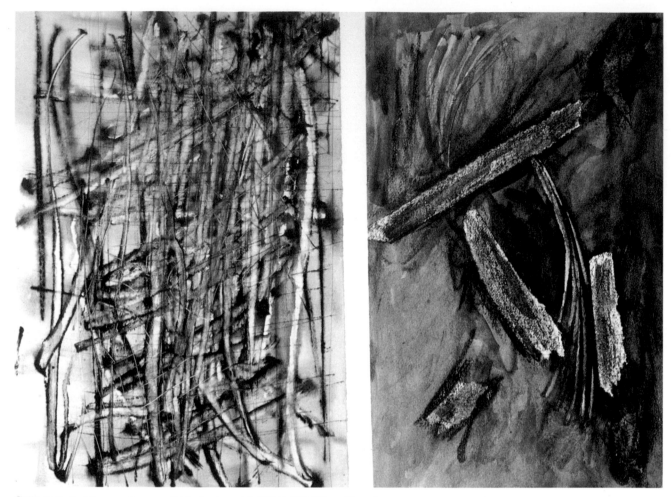

Colleen Tully, "Ocean Grayness" (student work), 30" × 20" (76 × 51 cm)

By laying a piece of masking tape across the center of the sheet before working, Colleen Tully has created a diptych—two separate paintings intended to be viewed as one. Although there are no flamboyant relationships uniting the two, some connections exist. Both contain depressed color, abundance of texture, and, most important, the marks of Colleen's ever-moving, slashing hand.

In the left painting she began with a series of sharply incised lines, cut in the dry paper with a knife. She then wet the paper and laid in the gray, yellow, and green colors. With a stick, she rubbed violently into the wet paint, making the fatter lines, which became more defined as the paint dried. When everything was completely dry, she sliced again with the point of a knife, which tore through to the paper and created thin white lines.

In the right painting Colleen tore masking tape, twisted it, and stuck it on the dry white paper to form the basis for the large white-edged shapes. Next she painted masking solution on, creating the feathery shapes. After laying on wet washes with squeegees, she removed the masking solution in stages so the feather shapes became multicolored. When everything had dried, she removed the tape and scraped black randomly across the paper, quieting all the shapes and pushing them into a murky abyss.

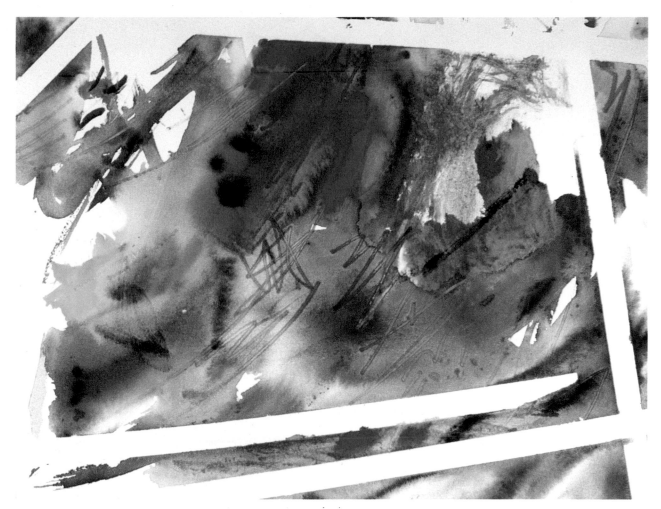

Royce Leonard, "Dark Winds" (student work), 10″ × 13″ (25 × 33 cm)

Royce Leonard has used masking tape to establish an out-of-kilter frame, roughly surrounding his various exploits within. Before dropping in paint, he sanded the bottom and used a wire brush at the top right, where the hairy green shape lies. He then worked with diverse techniques: wet-in-wet, salt, and scribbling with various instruments.

The mood of this painting is very different from that in Colleen's work. The purer colors here suggest a lighter tone, but the mark of Royce's hand is also distinctive. Where Colleen created a violent repetition of stabbing strokes, Royce has given us big, soft, amorphous shapes, and his calligraphy strikes a note of playfulness. This is not, by the way, a comment on the personalities of the two artists, just on their painterly intentions that day.

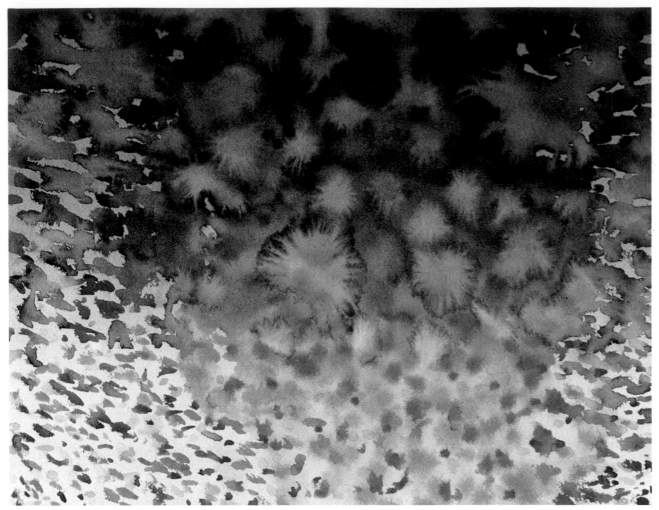

Julyn Duke, "Moonlight Sonata" (student work), 12" × 14¾" (31 × 37 cm)

Julyn Duke's painting suggests fireworks: small, dry shapes originate at the bottom edges, dissipate as they move up, and then culminate as exploding blooms of wet paint, cascading back to the bottom. To achieve this effect, Julyn first laid in the drier shapes and then added water in progressive amounts, until she reached the center zone, where she dropped in large amounts of water and more pigment. When you're working with such big puddles, be sure your paper is in a stationary, flat location, so it can dry undisturbed for hours. A hairdryer is useless with this much water, and may even be destructive.

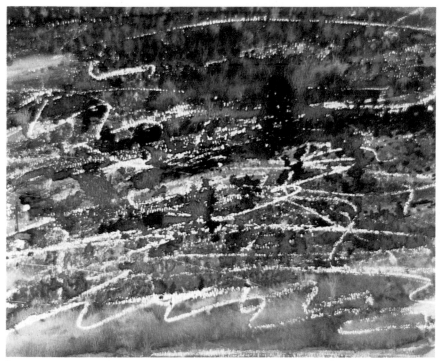

Deana Houston began this rendition of "Dark Winds" by making the scrambling lines with a white crayon. These lines remained as she dropped different colors into wash areas, varying in wetness, to form the horizontal bands across the composition. Close scrutiny reveals a myriad of small blooms and spots in this galaxy of blurs.

George Chow has projected a gentle, sweeping movement in this wispy texture painting. After laying in the blues and reds in a wet field, he dragged a credit card in a curving motion. He then punctuated this by using the same motion with the end of his brush. Overall I think there is a gentle balance of the soft, friendly colors and the swirling, muted textures.

Deana Houston, "Dark Winds" (student work), 11" × 13¾" (28 × 33 cm)

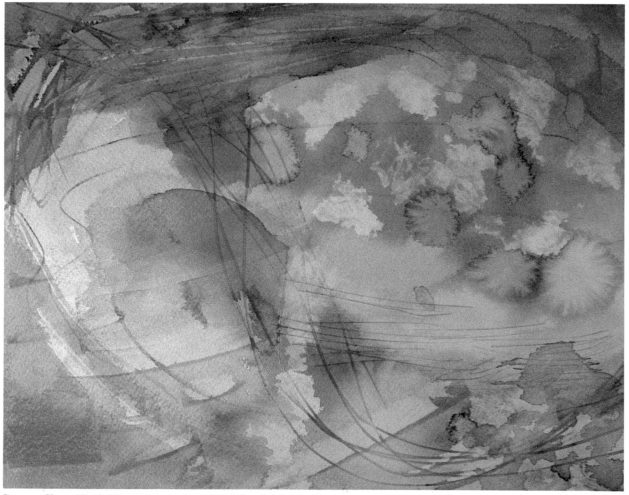

George Chow, "Dark Winds" (student work), 7½" × 10" (19 × 25 cm)

DAY 11
Linear and Other Beginnings

For all practical purposes there are three ways to start a watercolor. You are versed in two of them already: making a light pencil drawing and directly dropping in paint with a brush. It's time to look more closely at drawing with your brush and paint.

Day 1 included an exercise on the brush as a line-maker. You have probably used this technique in some of your paintings—to emphasize an edge, render a pattern, or just make lines for their own sake. What is the potential of line made with paint and a brush?

A line can have width. As you vary the brush pressure on the paper, the line thickens and thins accordingly. A spatial illusion is created, with the broader line usually appearing closer to the viewer and moving into space as it thins. Of course, this is not an absolute—it depends on the other elements in the painting.

A line can have value. As a line changes in value, its apparent position in space will change. Usually a dark line appears closest to the viewer, while paler lines diminish in the distance.

A line can have color. Red lines are aggressive and usually come forward in a painting. Blue lines are recessive. This is stating it bluntly; remember, the relativity of color can produce endless spatial surprises.

A line can emote. Short, staccato lines speak differently from long, undulating ones. Similarly, lines suggest different speeds as they move across the paper. The patterning, or rhythm, of lines can also invoke speed or emotion. By "emotion," I don't exactly mean happy or sad, love or hate, but more the way we individually sense and respond to the abstraction in all art.

To explore the potential of line, set up a still life with at least five objects of varying shapes and surfaces—the more unusual, the better. Try to include some plants or cut flowers, or similar "linear" material. The idea is to suggest as many kinds of line as possible with this setup.

With your no. 3 script brush, begin to draw from the still life directly onto the paper. Do not begin with a pencil drawing. Pay close attention to all the aspects of line discussed here. Experiment with very wet, as well as dry, mixtures of paint. Do not feel limited by the local color of the setup—

instead, change color frequently, at random. Also, remember that line does not just indicate edge—it can also move across objects, conveying their volume.

Use as much line as possible, moving all over the paper, even drawing over previous lines from time to time. Continue until you have virtually completed your painting. Then step back and take a look. You could be finished at this point, or you may want to indicate some planes with strokes of a broader brush. Just be careful to keep line dominant in the finished painting.

Juanita Cacioppo, *Gladiolus,* 12" × 5" (30 × 13 cm)

Juanita Cacioppo's lines began as a quick, gestural notation of the planes of the blooms, but in the end they became a dominant element, imparting a lively tempo, literally uplifting. Instead of cautiously rendering the clustered blossoms of a gladiolus, the lines serve as a dynamic abstraction, perhaps exalting the soul of natural beauty. And that is what art is supposed to do, isn't it?

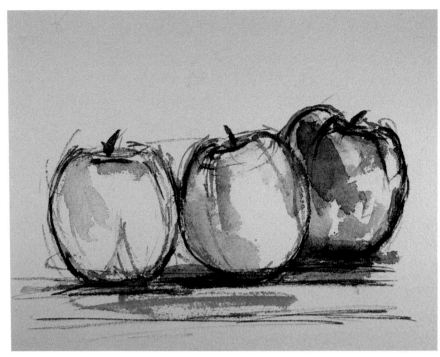

Michael Crespo, *Three Apples*, 8″ × 12″ (20 × 30 cm)

In this little "bare bones" painting, a type I often like to make, the idea of today's exercise is clearly indicated. I begin with very quick linear responses to what I'm looking at, changing color at random as I move along. I try to keep the paint very liquid, yet potent with pigment, so my marks are bold and visible. When I feel the line has satisfactorily depicted the forms, I lay in some secondary color planes to reinforce the volumes. I like to leave a lot of white, as this gives the illusion of a strong light source in a mostly linear treatment.

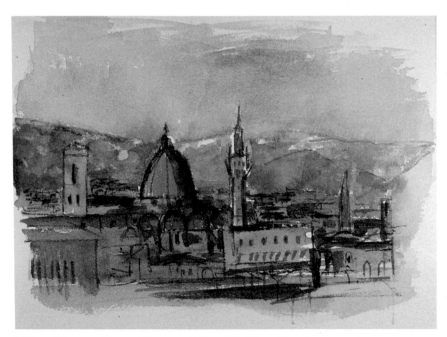

Michael Crespo, *View of Florence*, 10″ × 15″ (25 × 38 cm)

This view of Florence displays a different approach to a primarily linear treatment. I first laid in a gray wash and, while it was wet, began to describe some of the major plans of the composition: the mountains in the distance, the sky, and the darker gray band underlying the architecture. I let this "atmospheric" underpainting dry and then set about describing the city with a maze of lines. When the lines were dry, I went back in with some color planes to accentuate the skyline. This way of working results in a contrast of soft, generalized masses and hard, specific contour lines.

Ellen Ellis, student work, 13″ × 13½″ (33 × 34 cm)

Ellen Ellis presents a fine example of qualitative line, which varies in thickness and thus appears to be at different distances from the viewer. Notice the range from small flicks strewn across the composition to broad strokes in the plant, its pot, and the foreground. The widest strokes never depart from the realm of the line, with the possible exception of the green on the parrot's head. That stroke could be considered a mass. But it's really a philosophical argument as to when a stroke ceases to be a line. My point is that this painting is a celebration of linearity.

To grasp how line can explain the space occupied by an object, look at the leaves of the plant and the pot. The smaller lines provide different information from the broader ones. When you gaze across the entire painting, however, you realize that there is no set system—thin and fat lines appear both in the foreground and the back. Yet the eye translates these differences into space. It may not be an ordered perspective space, but it is a highly active visual situation. The thick and thin lines move us in and out, perhaps not in reference to the objects, but definitely in reference to the picture plane. Also note the variations in the color and value of these lines, which again lead in and out. Surprisingly, a relatively static still life is energized into a pulsing space by the quality of the lines.

I find the rhythm of line the most important aspect of this painting by Gloria Jalil. Notice how the lines of the intricate tablecloth act almost as quotation marks surrounding the basket of fruit. The lines on the right pulsate in unison to the right, while those on the left pulsate to the left. Within the fruit, the lines do not have any obvious cadence; they move in many directions. Yet they are contained by the most static of line structures—a grid—in the basket. The contradictions and repetitions all bring out the rhythmic potential of line.

Gloria Jalil, student work, 9½″ × 13½″ (24 × 34 cm)

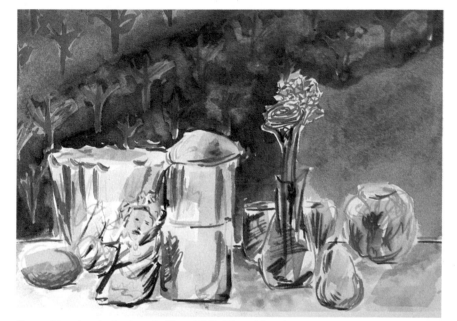

Bryan Murphy has used line to impart a slightly distinctive quality to each object. His line might be described as nervous, possessing a wound-spring tension. As a contrast to this taut feeling, he applied flowing planes of color, after establishing the linear structure.

I am always impressed at how line-making seems to disclose the individuality of the painter, sometimes even more than color choices. This exercise always results in distinctive expressions by the different students in my class. I am not proposing specific meanings, nor is such scrutiny really relevant; my point is just that decidedly individual stances are evident. Lines were probably the first artistic utterances by man, so why shouldn't they have power?

Bryan Murphy, student work, 9″ × 12½″ (23 × 32 cm)

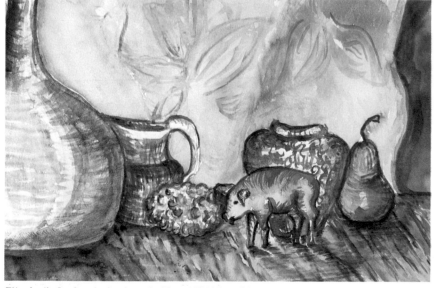

Elizabeth Jenks has painted an abundance of lines, forcefully contained within the contours of the various objects. No line is allowed to escape its designated object. These lines then take on a more obsessive, decorative role than lines that transgress and describe the entire space. The objects, which exist only within their own boundaries, seem to reinforce the static truth of inanimate objects.

Elizabeth Jenks, student work, 9″ × 14″ (23 × 36 cm)

DAY 12
Three Zones of Landscape

For the past few days, for the most part you have been painting objects that you carefully chose, positioned, and lit. With a landscape, however, you are faced with 360 degrees of subject matter, including every color, shape, value, and texture imaginable. To compound the misery, all of these change character constantly in the ever-moving light. Where do you begin?

You could just start painting at some point and work out to the edges of the paper. Although this is not always a bad idea, often the composition is left too much to fate. It is always better to have a structure, something to fall back on, something to give meaning to intuitive marks and techniques, something to allow freedom in response.

Let's consider the most common structuring of space: foreground, middle ground, and background. Obviously these zones are not specifically reserved for the landscape, but can be applied to still lifes, interiors, figures, and abstract works. Essentially, they are a way of categorizing what we see, of organizing it.

Look at the first drawing on the facing page, where the landscape is divided into three clearly distinguished spatial zones. Here the bright middle-ground water is isolated from the other two zones; it is fronted and backed by darker and more textured grass and trees. Working with basic pictorial elements, consider how you might juggle contrasts and similarities in developing this composition:

- *Light*—place darker values in the foreground and background, and saturate the ground with lights. Or make the middle ground dark and let lighter values dominate the foreground and background.
- *Color*—make greens dominate the foreground and background, with blues, yellows, and grays in the middle ground.
- *Focus*—keep a sharp focus in the middle ground, but avoid sharp edges in the foreground and background.

If you decide on three clear divisions of space, it's easy to organize the various pictorial elements.

I've mentioned only one possibility—isolating the middle ground. Any combination is possible. The focus could occur in the background with the foreground and middle ground left unfocused and fused together. Just be careful not to follow any structure too stringently. Let some similar elements exist in all three zones. If these areas are not related in some way, your picture will flatten into stripes.

While we are examining compositional zones, let's take a look at what is called a *repoussoir*. This compositional device can be found in landscape paintings over many generations—see, for example, the paintings of Claude Lorrain, Salvator Rosa, and Jean Baptiste Camille Corot. What is involved is a kind of spatial contrast. There might, for example, be a dark frame running down either the left or right side of a painting and across the bottom—composed perhaps of a tree and its shadow. Immediately behind this repoussoir would be an area of bright, contrasting light. Some of the more inventive landscape painters incorporated a few lights into the repoussoir itself to echo the light behind. In this way they kept the "frame" from appearing too flat. They might, for instance, include a shepherd asleep at the base of the tree, with his shirt and features faintly lit.

To understand these ideas, venture outside and find a motif that generally fits into the three-zone scheme. Make a number of thumbnail sketches, trying out various configurations of the zones and what occurs in them. When you feel you have an idea of how to proceed, sketch in a light pencil drawing and begin painting with your compositional concept in mind. Paint as directly as you can in this painting—don't get bogged down in technical considerations. Also don't worry if you've never painted a tree. We'll study the parts in the next lesson. For now, do the best you can. Simplify your forms. Keep your value range intense and your colors varied. As I stated before, remember not to overstate the system. In general subtle transitions will draw the eye across the space most easily, although sometimes an abrupt transition may be desirable.

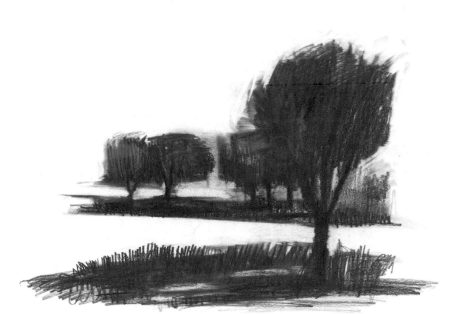

This drawing defines three zones, differentiated by value. The isolated middle ground is contained by a dark foreground and background. The eye moves into the space from the foreground, across the middle ground, to the background because of the strong relationship. Or the eye may situate itself in the sequestered middle, well aware of the two related zones swaddling it.

In this drawing the value plan has been reversed, with the foreground and background in light to middle values and the middle ground distinctly dark. The highlights on the water help to make the transition from front to rear. Focus also plays a part in this scheme. The foreground and background are for the most part out of focus, in contrast to the hard-edged middle ground with its sharp highlights.

This is the same landscape, but now color is used as an agent of contrast. Sandwiched between the dominant green foreground and background is a blue lake. The brief highlights of yellow along the banks join with the blue to wedge apart the two zones of green.

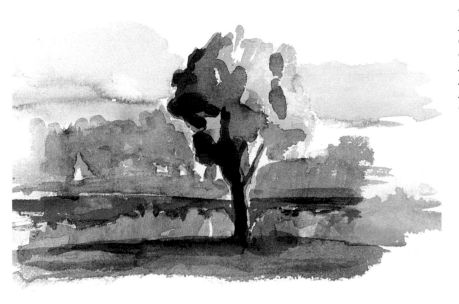

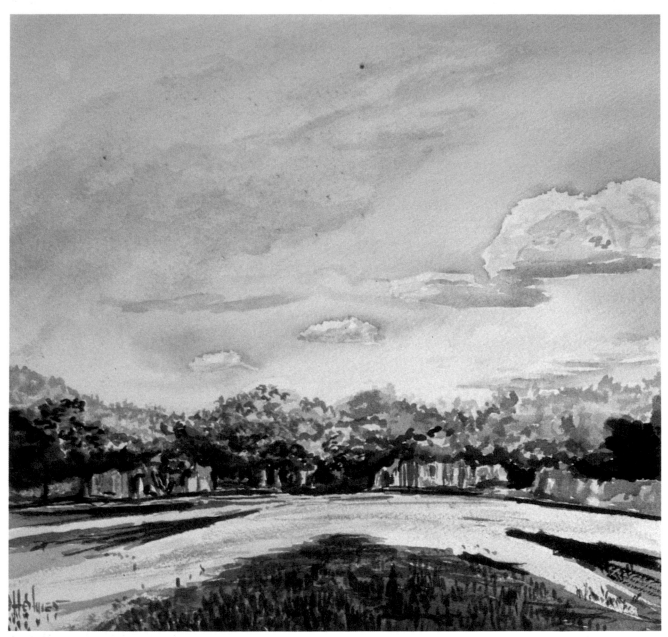

Joe Holmes, student work, 9″ × 10″ (23 × 25 cm)

The concept of three zones may be crystal clear, or it may venture into spatial irony, as in this painting. Joe Holmes envisioned the bright, X-shaped yellow path as the middle ground, held in place by the textured, dark green foreground and background. The irony, which makes for a wonderful spatial transition, is that this yellow plane intrudes on both the other planes and yet still maintains its integrity as the middle ground. It arises from the right and left corners of the foreground, and its yellow hue permeates the tops of the background trees.

There is another question raised by this painting that flaws the "perfect" theory of today's lesson. What zone does the sky belong to? You might say that the sky is above all three zones and therefore shared by all. But skies can easily be grouped with the background, or they may remain aloof from the system, with the spatial zones occurring solely on the ground. Joe depicts the sky as above all three zones. Notice how he has drawn the clouds in perspective, making the sky move toward the distance, echoing the spatial thrust below, on the ground.

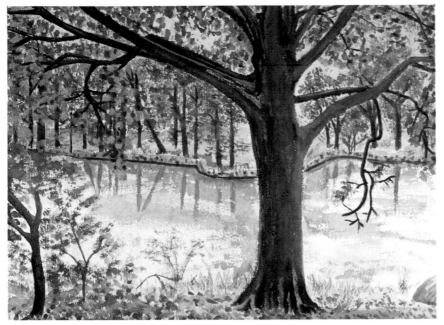

Gloria Jalil, student work, 11″ × 15″ (28 × 38 cm)

Texture dominates this painting by Gloria Jalil and helps to both distinguish and unite the spatial zones. The foreground and background are both painted with many stamped brushstrokes. Although there is some texture in the middle ground, the values are close, making it seem untextured when compared with the other two zones.

Marcy Blanchard has used color to separate the three zones. The middle-ground green is situated between the related warm grays of the other two grounds. The greens on top might belong to the large tree in the foreground, the trees in the middle ground, or the little trees in the distance—a very clever ploy. At the bottom, the green moves the eye into the foreground through the shrubs and muted scrub grass.

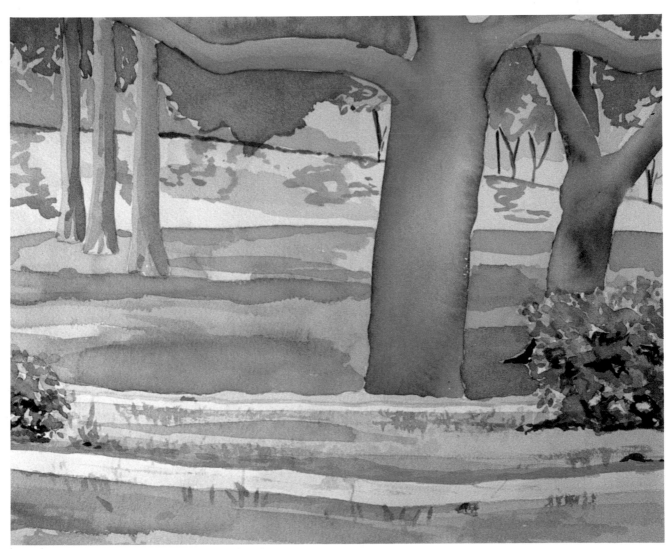

Marcy Blanchard, student work, 11″ × 14″ (28 × 36 cm)

87

Christy Brandenberg has thrown the proverbial monkey wrench into this one. For the time being, ignore that blue triangle, or swimming pool, on the right. The foreground is marked by a dark tree, with some clumps of shrubs surrounding its base. The middle ground is then the flat green expanse leading to the other trees, the fence, and the house. The trees in the background are dark and also have shrubs at their feet, forming an obvious connection with the foreground and its similar tree. But then we have that blue swimming pool, which blatantly disturbs the tranquility of this order. It does direct us into the space, but it is most eccentric in placement, as well as being a mildly unexpected color. Christy has created a delightful moment that works because of its sheer arrogance, puncturing a spatial system she probably considered too stoic.

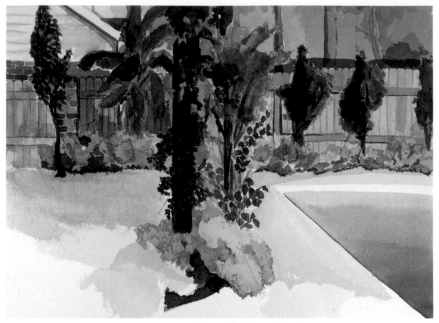

Christy Brandenberg, student work, 12″ × 16″ (30 × 41 cm)

George Chow poses another variation on the theme. All three zones are different. I consider his sky the background zone, the building and trees the middle ground, and the flat, shadowy, yellow-green lawn the foreground. The clarity of the scene allows the eye to make the transition between the zones—from field to architecture to sky. There are also color connections: the white of the clouds moves into the white of the building, and the yellow-green of the field is repeated in the trees on the right. It's simple and effective: one, two, three.

George Chow, student work, 9½″ × 12″ (24 × 30 cm)

This drawing shows the classic repoussoir, in which the dark tree and its shadow frame the rest of the composition and also create an interesting spatial tension.

Joel West has used the classic repoussoir, with a large oak on the left that casts a shadow across the bottom of the picture. This dramatically frames the rest of the space, in which more oaks pierce through the picture plane in a line of perspective. To exaggerate his repoussoir, Joel increased the color temperature as he moved away from the framing device. Also notice the softly modeled tree trunks, which mesh with the multi-layered strokes of the foliage.

Joel West, student work, 10½" × 14½" (27 × 37 cm)

DAY 13
Landscape Components

Today let's look at some basic elements of landscape painting. Keep in mind that there are innumerable ways to paint any subject, and feel free to venture beyond the particular techniques presented here. Use this exercise as a starting—not a stopping—point. Take your equipment outside again and try the methods described here; then continue to experiment and to expand your working methods.

handle almost parallel to the paper, rather than at the normal ninety-degree angle.

You can also squeeze the brush dry with your fingers and then splay the bristles by pressing them on your palette. Use dry pigment with this newly formed brush and experiment with stroking, dabbing, and dotting gestures. Remember that the look of your drybrush marks will be greatly influenced by the roughness of your paper.

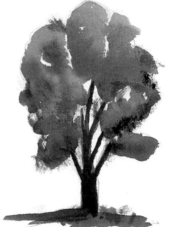

Tree Silhouettes. Familiarize yourself with the underlying forms of as many trees and shrubs as possible. Practice painting flat silhouettes of specific tree shapes. Use sepia, umber, or sienna. Do not make a pencil sketch; instead, start with a loaded brush and define the tree or bush shape as accurately as possible, starting in the center and working out to the contour. Paint single forms first, then mass groups of trees into a large shape.

Basic Tree Study. First sketch a tree with pencil. Lay in the foliage with a light wash and, while this is still wet, lay in a darker value to suggest volume. Since outdoor light generally comes from above, keep the first, light wash visible at the top of the clumps. When your two washes have dried, add a few dark drybrush marks for emphasis and then paint the branches and trunk.

Drybrush Practice. This is a good time to review drybrush technique. Basically "drybrush" means skimming the surface of the paper with color, depositing that color on the rough-textured "hills" of the paper. As the term implies, your brush should be relatively dry, not loaded with paint. To keep your brush on the dry side, pass it over a tissue or sponge before applying the pigment. Then, to make your strokes, hold your brush

Grass. Paint the overall shape of grass and weeds as a silhouette; then complete the contours by using a variety of drybrush marks. Add darker values and accents to build the form. Before the paint is dry, use your fingernail, a razor, or a knife to scratch in a suggestion of individual blades of grass.

The "Forest." Sit in front of a bush. Choose a small area of the bush at random and loosely record your impressions. Work wet-in-wet over the whole mass, establishing various shapes and values. Let the paint dry a bit and then lift some of the paint to create a light source. Finally, after everything has dried, indicate some of the darker positive and negative shapes.

Next, using the same approach, paint a larger subject, such as a row of hedges or a forest. This exercise will help in situations where there is an abundance of intricate information, but you want only to convey a "sense" of the subject.

Skies. Skies are always a delightful painting experience. John Constable's numerous studies of clouds are testament to his passion for these ever-moving, ever-changing masses. Already, in working with washes (Day 6), you've learned the basis of sky painting. Using this knowledge and experimenting with several different color combinations, explore three basic approaches:

● *Clear Sky.* For this situation, use a simple graded wash, or a flat wash.

● *Cloudy Sky on Dry Paper.* Sketch in the cloud shapes with a pencil; then rapidly paint in the surrounding blue sky. Soften some of the edges with your brush. Mix a gray for the cloud shadows and paint them in. Let everything dry; then paint in darker grays, as well as darker blues in the sky, to increase the value contrasts.

● *Cloudy Sky Painted Wet-in-Wet.* First wet the sky area with clear water; then paint in the cloud patterns. Add a second color to the wet surface; also add darks where needed. Work quickly so the paper does not dry and so no hard edges form.

Elizabeth Jenks has produced a page full of very fluid, spontaneous gestures. These simple configurations may be all that is needed to render a tree effectively. Too much deliberation with the brush can lead to stale, awkward renditions of trees. Instead, try composing an entire painting with simple silhouetted markings like these.

George Chow's stylized, contained approach is evident in these studies. Notice his skillful use of value and delicate mixing of color in each form. Also notice how, on the right, he has combined the tree and grass in a mini-composition.

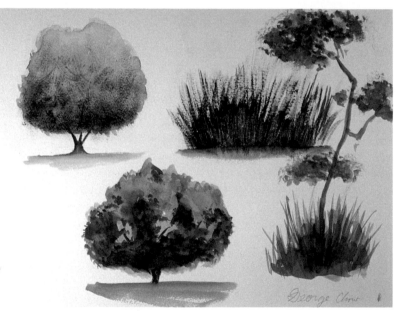

Bryan Murphy crammed this page with a variety of exercises. At the top left is a wet-in-wet cloudy sky; below is a cloudy sky done on dry paper, as well as a grass study. On the right is another cloudy sky sketch, with two examples of the forest exercise below.

I like my students to approach this assignment with a certain nonchalance—as if, after the "serious" paintings they've done, these little exercises didn't really count. This relaxed attitude fosters spontaneity. You might compare this exercise to doodling in a phone book. And you may be surprised at what you learn. I discovered how to model basic forms by filling legal pads with scribbles during faculty meetings.

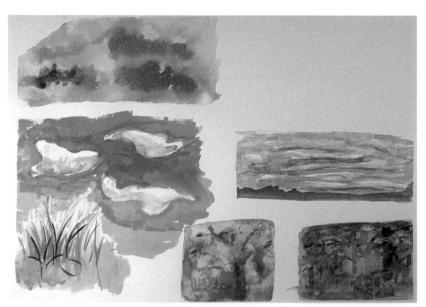

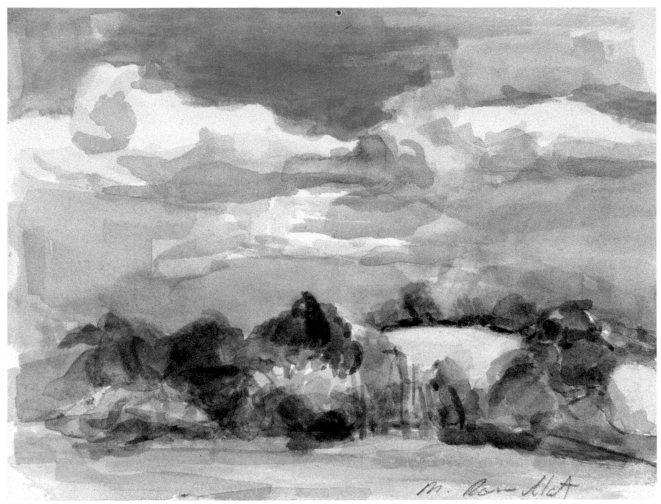

Marcy Rosenblat, *Landscape*, 6″ × 7½″ (15 × 18 cm)

The magical little landscape by Marcy Rosenblat exemplifies two of the exercises you have just practiced. The earth, with its meandering strokes, is a sophisticated version of the nebulous forest exercise, while the sky represents the classic treatment of cloudy sky on dry paper.

In Venice I've encountered almost every kind of sky. On this particular day it was as if the scene instructed me to wallow in wet-in-wet. Color evaporated into misty blue-grays, and the water and the sky became one, demanding the same technique. At times I wondered which was reflecting the other.

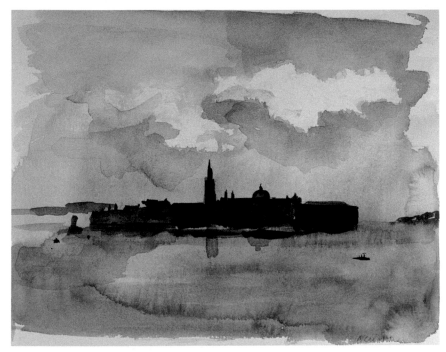

Michael Crespo, *San Giorgio Maggiore*, 9½″ × 12½″ (24 × 32 cm)

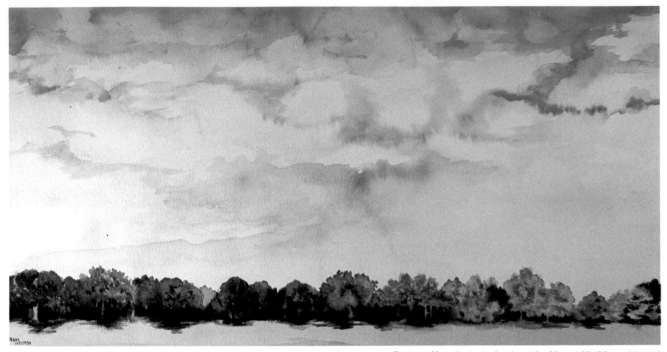

Deana Houston, student work, 9″ × 18″ (23 × 46 cm)

In her striking horizontal composition, Deana Houston has put the exercises to work. She first silhouetted the line of clumped trees along the horizon, then painted them in the "basic tree" manner. The sky, done wet-in-wet, is what I call a "Sara Lee cheesecake" sky, for the clouds resemble endless squirts from a pastry bag.

Marcy Blanchard mingles warm, brownish-gray clouds in a mottled blue, wet-in-wet sky. She has carefully worked over the wet painting with tissue, pulling out pigment for the dappled effect. Be sure to look at the cloud studies by Constable, which demonstrate the power of painting the sky alone.

Marcy Blanchard, student work, 7″ × 11″ (18 × 28 cm)

Elizabeth Jenks has combined the basic tree exercise with a wet-in-wet sky to produce this vivacious landscape. The lively coloring comes from her use of an acrid yellow underpainting and the way she has perched the two cool, blue-green trees in the multi-colored field.

Elizabeth Jenks, student work, 10½″ × 14″ (27 × 36 cm)

Marcy Blanchard, student work, 7″ × 11″ (18 × 28 cm)

Marcy Blanchard wove this intricate, spidery web while staring into a bush. The color is analogous and hot; the technique, wet and fused. Practicing this "forest" exercise can help you when you encounter vague, tangled spaces that you want to imply but not describe.

DAY 14
The Painterly Middle Space

Imagine a day in winter. The blue sky has bled to gray, the sun is absent. Color and value are present, but have been washed slightly gray. This is a good example of the middle space in painting. Jack Wilkinson, a great friend and teacher of mine, was a master landscape painter, and his work was laden with lessons in the middle space. He taught me many things, one of the most important being a clear understanding of the quality called *painterliness*. And that is what we'll shoot for today—painterliness. Some of you may have forgotten the lessons of Day 1 on wielding the brush. Today should inject some passion into your stale brush.

When you limit color and value, they are much easier to control, for you are working with much slower transitions. Recall the discussion from Day 2 on the relative slowness of grays compared with purer hues—the same applies to value. Imagine a black-and-white checkerboard and a middle-gray or slightly lighter checkerboard. You can easily sense the contrasting speeds.

So now you have grayed colors (which are closely related in their grayness), as well as values that cluster around the middle of the scale, close and comfortable. Given all this inertia in color and value, you should feel free to wield your brush with more reckless abandon. There are no great color errors to be made—the grays all sit richly together. And if your values do not

provide dramatic contrasts—well, that's just how it should be for this exercise. The space—the middle space—of the landscape will be different from what you've encountered in the last two lessons. It will be close, contained, and flatter. But, in this limited arena, you can find a new life in your brush. That muted winter day I asked you to imagine is nature's lesson in limitation, and in painting, limitation is often the threshold to freedom and expression.

It would be simple to paint that bleak winter day, but it's not necessary. You can observe the middle space in any landscape on any given day at any given time. I would suggest that you choose a scene dense with foliage to give your brush motions a little more exuberance. Use a limited palette—alizarin crimson, ultramarine blue, cadmium yellow, and black—and keep your color grayed, except for focal points. Also keep the values very close, clustering them more in the middle than you would in the normal value system. Use lights and darks for punctuation only. Do away with traditional representational focuses, and let brushmarks of accented color and value be the only focal points.

Be certain to let your brush run rampant in this painting. Let it caress forms as your eye does. Let it convey your feelings about yourself, this day, and this landscape. Meditate, and paint within this subconscious. Speak *your* language.

Deana Houston has discovered that "imaginary day in winter" I described. By carefully holding the value and color intensity within a very limited range, she has imbued the scene with a very sober light. The brushwork, however, is anything but restrained. Moreover, Deana has plotted a number of subtle, but enlivening color changes, the most dramatic of which is the dusty red lurking behind all those greens.

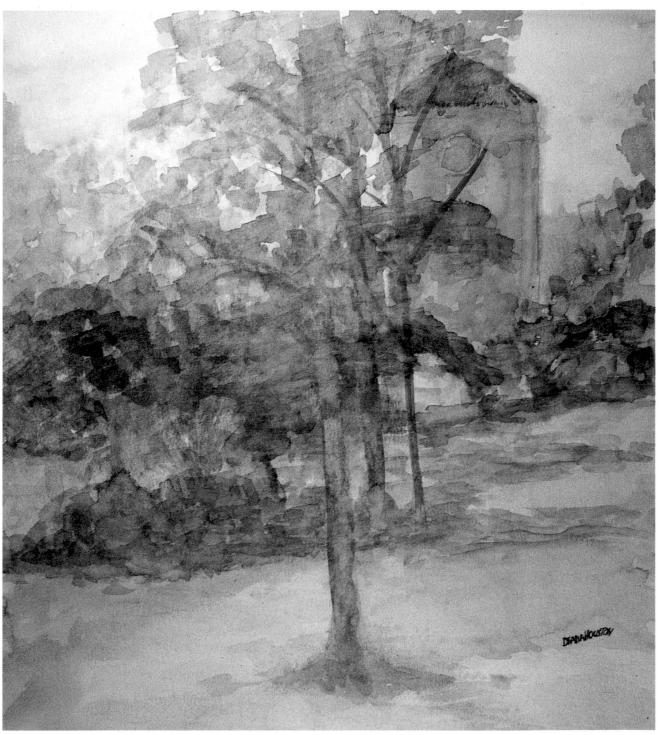

Deana Houston, student work, 17″ × 15½″ (43 × 39 cm)

Patricia Burke, student work, 10″ × 15″ (25 × 38 cm)

Patricia Burke's rapid, immediate brush responses enhance the painterly quality of this landscape. She has maintained the close value range of the middle space while leaving small, crackling paper-whites intact to illuminate forms in the chaotic mass. A few rambling darker values lead us from the bottom left across the tree and back into the bushes. Despite the drastic reduction in color intensity, there is a remarkable range of warm and cool tones, which dance around the vigorous shapes.

Observe how the "space" of this middle space works: it is relatively flat, punching into the picture plane occasionally, but there is just enough to give some weight to a form. Also notice that although you can discern the tree and a few shrubs, the focus is not really on the perceived objects, but on the elements of the craft itself: the brushwork, shapes, values, and colors. Finally, consider the importance of the one contradictory color note: when the line of bluish color moves away from the tree to culminate in the pure red spot, which screams its independence in this exemplary middle-space painting.

When I consider Marcy Blanchard's characteristic hard-edged approach, this painting seems explosive and arrogant in its brushwork. It's a good example of how a different problem can expand your repertoire.

Marcy has inched her limited palette into a formidable color scheme. Everything is permeated by an initial grayed-yellow wash. The dominant warm tones are then challenged by the complementary purple that moves across the center zone. In the restricted world of this problem, Marcy has discovered a vibrant sense of light. And it is as if the very restriction made this light peculiarly intense.

Marcy Blanchard, student work, 11″ × 14″ (28 × 36 cm)

There are always a few renegade students who just have to burst through restrictions whenever they can. Scot Guidry is an exuberant person, and I can't imagine him finding any comfort in graying his color too much. The color here may be a bit too strong and the value too wide-ranging, but his brushwork decidedly promotes the middle space. Despite the deep space implied by the high horizon line, the character and energy of his marks stay right up in front, on the picture plane. The soft, but agitated, wet marks at the bottom move on to the more whimsical slashes of the trees and sky. The central focus is on the yellow and red construction equipment, but notice that this machinery is exposed as a series of negative shapes by the green mass of trees.

Scot Guidry, student work, 12″ × 16″ (30 × 41 cm)

DAY 15
Expanding Color

On Day 3 I discussed dominant color and suggested some color schemes. I trust you've been using them, or at least testing them. Today, we'll experiment with another color structure. This one doesn't work because its obvious, it works because it's ironic.

Irony is as natural in painting as color. It exists in much the same way as it exists in anything else—as an expression of the opposite of what one really means, or incongruity between the actual result and the expected result. We've had dealings with it all along. It's hard not to when you're shifting from three dimensions to two. Today, odd as this may sound, we'll make a definitive statement of space by manipulating the scale and chroma of color to contradict perspective.

The theory is simple. A small amount of a color located in the foreground of a painting exists in the background as a large amount. The irony is also simple. We use perspective to get from the foreground to the background, with objects becoming smaller as they move back and colors fading to gray. But when there is a small amount of blue, isolated in the front, or bottom, of the painting, and it expands into a sky in the back, or top, there is reverse perspective, or irony. This is true two-dimensional space-making. A little purple car in the foreground drives down a highway that diminishes, tree by tree, into a big purple mountain. The purple mountain is bound by perspective and logic to the background; but the same perspective also dictates that the large purple shape is closer to us than the small one, entitling the mountain to reverse its position with the car. The cycle repeats itself again and again in our eye. The space is alive and active.

My class always gets a charge out of the setup for this exercise. They refer to it as the "cup in the desert." I use a beautiful, old, hand-painted Mexican coffee cup. The array of bright colors offers many options for a background. I intricately fold and roll a neutral-colored drape and place it between the cup and the wall. This establishes a middle ground to separate the expanded color. As in most of my still lifes, the subject is dramatically lit.

Try to reproduce my setup as closely as possible. This setup may seem overly simple, but after all the landscape painting, you may enjoy the return to basics. Moreover, the decorative passage on the cup and the drapery folds can provide complexity, should you want it.

Paint directly from perception at first, clearly marking the small color passages in the foreground. Then paint the wall, or the space beyond the folded drape, with one of the isolated foreground colors. Once this expanded color is in place, the importance of the simple structure should be manifest. It seldom fails. Apply the principle to other motifs—look for it in nature, or conceptualize it if it doesn't exist. Be certain to tuck it away in your repertoire, for many painting problems can be solved with expanding color.

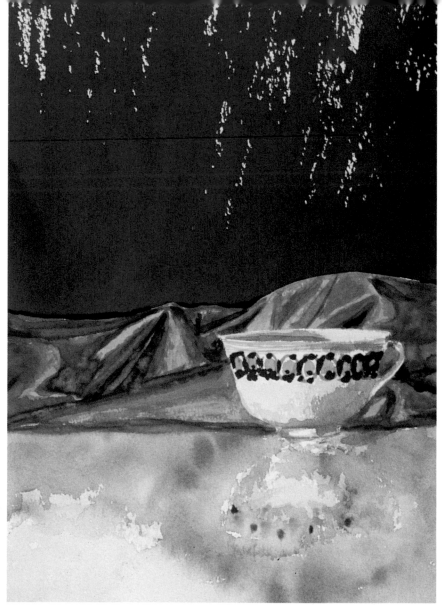

Gloria Jalil has transformed a simple still life into a bundle of visual events. The expansion of blue is direct and powerful. If you enter the painting from the bottom, you first encounter the blue as small, reflective specks on the ground plane. You then move to the source of the reflection in the decorative band of the cup. Finally you move back in the painting to the large mass of brilliant blue. The reflection of the cup on the broad ground plane, the elliptical top of the cup itself, and the folds of the drapery all take you back in space to the brilliant blue wall.

There is an irony in all this. Perspective dictates that things should get smaller and vaguer as they recede. This blue, however, gets larger and more intense, making the wall strive to be first in our eyes—which it is. At the same time the orange drape clearly separates the wall from the related blue dots in front and keeps forcing it to remain in its place behind everything else. The result is a lively visual tension. Also intriguing is the shower of paper-whites that rain in from the top of the painting. What a wonderful effect!

Gloria Jalil, student work, 13½" × 9½" (34 × 24 cm)

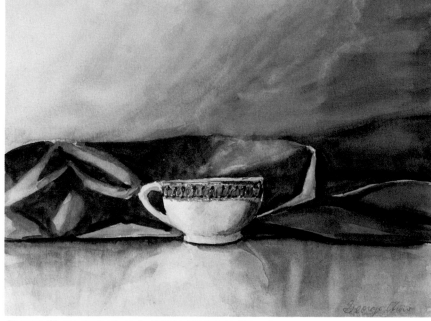

Working with the same still life as Gloria Jalil (above), George Chow has taken a very different approach. Here the dominant hues are warm, with a single, isolated patch of contrasting color in the cup's band. George has taken the small, bright orange from that band and expanded it into the background plane, washing it in like a sky. That windy plane of color then shines down into the rest of the painting, further strengthening the little blues and greens that surround the source color. Within this system there is still a reverse perspective, or irony. Notice especially how the dramatically rendered folds of the cloth move the eye back while the orange "background" drifts forward.

George Chow, student work, 7½" × 10" (19 × 25 cm)

By lining the three objects up in a row, Marcy Blanchard established a strong two-dimensional structure, which allowed her to inject two systems of expanding color. In the immediate foreground, a couple of orange blurs are expanded in the drapery, with the objects as the buffer zone. At the same time, the isolated violet band on the center cup expands into a large violet background. Both systems neatly intertwine, giving us a more complicated system and spawning a more comfortable color logic.

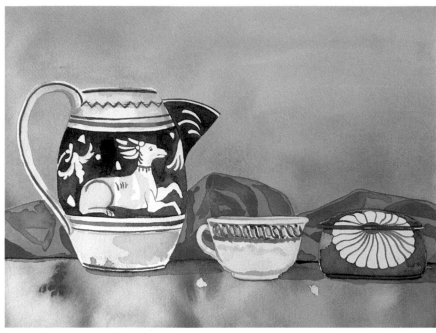

Marcy Blanchard, student work, 9½″ × 12½″ (24 × 32 cm)

In Jonathan Drury's painting, the vase and two apples lie on the same line, asserting their place near the front. Behind them lies a band of almost white light, before the wall of spotted fabric. The expanding color is obvious: the circular blue area in the vase expands to the back wall. The variation here is that objects do not form the separating zone; instead, an area of intense light divides the blues.

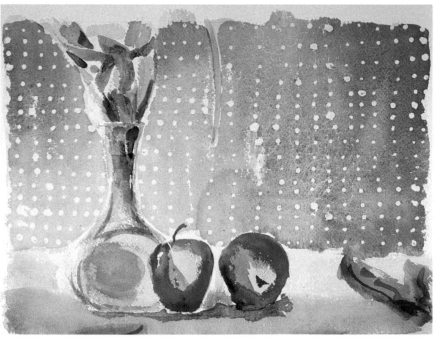

Jonathan Drury, student work, 9″ × 12″ (23 × 30 cm)

Karen Wright, student work, 12″ × 16″ (30 × 41 cm)

The six diverse objects in Karen Wright's still life help to control the
expansion of that most domineering of colors, red. The red is patterned
in different sizes and shapes across the foreground and then plastered
across the background. The red stripes lead the eye back in perspective
to the red wall, which then pushes forward. The complexity of the objects
keeps the red from overwhelming the painting and provides an
important counternote to the strong back-and-forth movement of per-
spective and color. Also note the tension created by the lively, decorative
pattern on the left. This area pushes forward even more forcefully than
the right. I think we have here a strong case for shape affecting the role
of color.

DAY 16
Backlighting

So far we have been working primarily with frontal and side lighting, which usually create contrasting lights and darks on objects and are thus conducive to rendering volumes. Backlighting, however, flattens objects into dark, well-defined flat shapes. The space surrounding the forms is usually very flat as well, with an abrupt shift from the dark ground plane to the light-filled background. Backlighting can thus dramatize the space, making for exciting paintings.

A good way to observe backlighting is to position a still life in a window, ideally on a sunny day, at a time when the light outside is at its greatest intensity. You need only use a couple of objects, as the window and view through it will provide more subject matter. Turn off any lights in the room and work only in natural light.

Of course, you can also produce backlighting artificially. Simply position spot or floodlights behind a setup, aimed in a direction that will not interfere with your vision.

The challenge in this exercise is to combine two value systems in the same painting, abutting on a line like weather fronts before a storm. Turn back to Day 5 and review the high- and low-key color and value systems. The foreground and objects are in a low-key system. Because there is very little value modulation, you must suggest volume through color variations. Use rich, dark hues to swell the flat object shapes into subtle volumes. Paint the background in high-key color and value, again varying color to produce movement within the restricted system. Do not understate the contrast of dark and light—intensify it.

Joe Holmes uses a mostly white background to bring out the backlighting. Within it are some very light abstract shapes, which keep the plane active. The objects are characteristically dark, and the cast shadows go forward—another quirk of backlighting.

Keep in mind that backlighting tends to destroy volume. Here the color variations, especially in the shell, and value modulation in the dark range help to create gently swelling forms. There are also some strong lights on the front of the objects, which do much to establish volume. Don't use too many of these frontal lights, however, as they can destroy the effect of the backlighting. Backlighting should be severe; if it's not blatantly obvious in your painting, it doesn't exist.

Joe Holmes, student work,
12½″ × 9″ (32 × 23 cm)

Lori Hahn's soft-edged brushstrokes provide a minor, but effective, contrast to the sharp, dramatic lighting. She has strongly emphasized the plane of light on the ground just behind the objects by making the dark foreground end abruptly at that point. Also notice the reflection of that ground-plane light in the bottom right of the vase. Always look for these little idiosyncrasies of light in nature, and make the most of them in your work. Light can be a beautifully diverse voice in painting.

Lori J. Hahn, student work,
13″ × 11″ (33 × 28 cm)

In Bryan Murphy's painting, the faint yellow background and dark, opaque shadows, looming in the front, clearly establish the light. Bryan first modeled the objects with dark, somber tones, but then he allowed his instincts to take over and began applying intensely colored strokes in a wild flurry. The backlighting, however, is not lost, and the objects take on new identities, which might never have been found otherwise.

Bryan Murphy, student work, 12″ × 15″ (30 × 38 cm)

This scene, which deviates a bit from normal backlighting, was presented to me late one evening in the Boboli Gardens in Florence. An intense sliver of evening sun slipped in between this sculpture and a dense, dark thicket in the rear. The problem, which excited me, was to paint backlighting without flooding the background with high-key colors surrounding a dark object. On the contrary, the background was the darkest part of the painting. I met this challenge by painting the dark front of the sculpture in middle-value colors and letting the white of the paper, the only indicated source of light, wrap around the statue wherever it could.

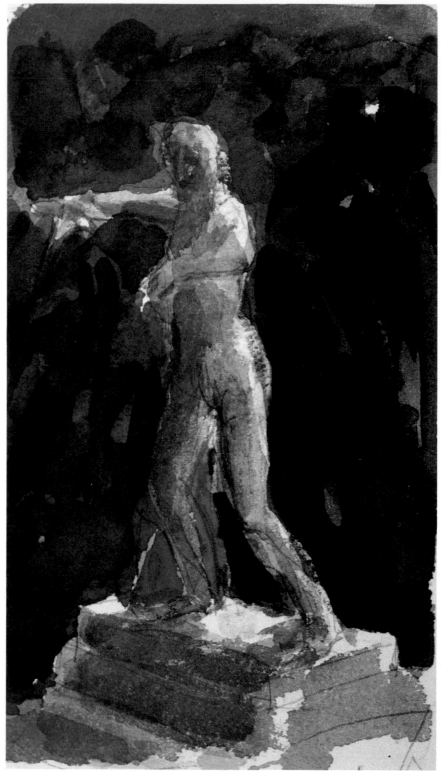

Michael Crespo, *Il Pescatore*, 8″ × 4½″ (20 × 11 cm)

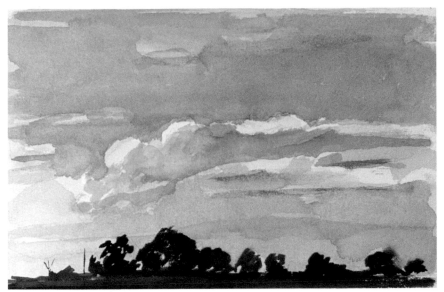

My wife Libby made this painting just before Hurricane Bonnie came ashore, when the landscape was dramatically backlit by a light sky. Notice how she has kept the trees and horizon flat and dark, unlike the still life paintings here. This choice emphasizes the curiously illuminated cloud that hangs over the tree line, defying the backlighting effect below. René Magritte made a surrealist painting of a house and trees in the dead of night, with a sky in the light of the day. The effect of light in Libby's painting, however, is not an invention, but a study of natural light, as presented by Hurricane Bonnie (not to be outdone by Magritte).

Libby Johnson Crespo, *Before the Storm*, 5½" × 8½" (14 × 22 cm)

These two bromeliads share my studio with me. One hot, yellow afternoon I set them in a window to get the full effect of the light. The plants looked almost black as I painted, staring into the sun. I used a full-strength chrome yellow to set the pace and then began layering blues, greens, and violets, trying to veil the plants, pots, and windowsill in obscurity and yet maintain some volume and surface texture. I had to somehow render sensations on the paper, for the objects gave me very little information. This kind of predicament is quite common when you're painting from nature. The idea is to welcome it and lunge in to paint that unknown solution that must come from within yourself.

Michael Crespo, *Bromeliads in a Window*, 14" × 19" (36 × 48 cm)

DAY 17
Two-Color Limit

Some of Winslow Homer's most breathtaking watercolors are those of boats and fisherman out in the Gulf. The color and the light are rich and accurate. After scrutiny, I have always been impressed with how very few colors he actually employed to produce this rich, though subtle, color field. I have always held that a good colorist is measured more by what he or she can do with a couple of tubes of color, not a boxful.

With the "middle space" exercise, you limited your color to the primary triad and black. Theoretically, all colors can be mixed from the three primaries, although in practice it's almost impossible. Now I'm going to restrict you to only two colors. It may take some struggle and ingenuity, but consider that if you choose two complements, such as blue and orange, you have at your disposal these colors in their pure states, as well as a neutral gray, orange-grays, and blue-grays. This is not as much of a limitation as it would seem. Moreover, there can be just as much implicit color activity with two more analogous

colors, such as green and violet, or even green and blue. It is important to realize that if you present a color in two different values, it can appear to be two different colors. A strong sense of light can thus produce an effect of more color than is actually there.

For today's exercise, use a traditional bouquet of flowers. Although this is not necessary, you might set them in a clear glass vase to increase the activity of the subject and the value complexity. You might also select multicolored flowers to augment your incentive to seek color variation.

Choose two tubes of color from your box. It is not necessary to use the two that give the *most* variation—Homer produced stunning effects with burnt umber and blue. Once you have chosen your colors, for whatever reason, stick with them; a strong commitment is an asset here. As you paint from the still life, surprise yourself—do whatever you have to do to make this painting work. Any possible technique or expression is applicable.

Finding diverse color can be difficult when analogous colors are employed, as in this painting, in which I used violet and green (viridian, to be exact). I quickly discovered I could make a rich black, which became the center of a broken field of frenzied marks. Although I did develop a suitable range of colors, I felt that using an array of techniques, with different textural qualities, would give the illusion of more generous color offerings. I scratched, stamped, overlaid, lifted, wet, and masked— the theory being that more of this may just make more of that.

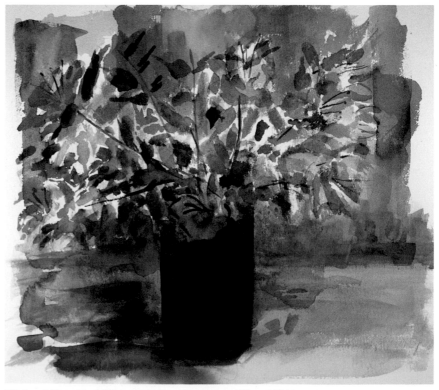

Michael Crespo, *A Vase of Azalea Blossoms,* 18" × 20" (46 × 51 cm)

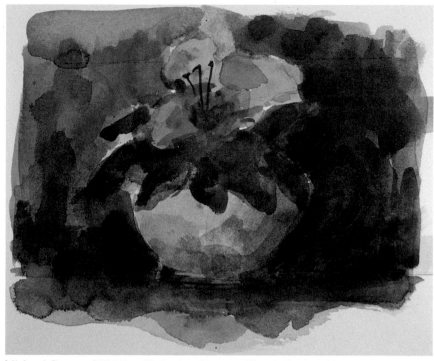

In the painting on the left I used only burnt sienna and ultramarine blue. I played heavily on a light value of the pure sienna, surrounded by mixtures of the two colors in much darker values. I also used a bit of pure blue in the area to the left of the flower. There's obviously a range of colors to be mixed from these particular hues and a lot to gain from exploiting their temperature contrasts. I love this problem because it invokes deception. You have to make wily use of color and everything else: value, texture, mixtures, transparencies, and so on.

In the painting below I used red-violet and cadmium yellow, but I did not use these colors full strength. Instead, I took a less obvious approach and explored the rich variations within the brooding grays. I also used the lighting to create a drama that thrives more on value than hue.

Michael Crespo, *Still Life with Azalea Blossom*, 7″ × 8½″ (18 × 22 cm)

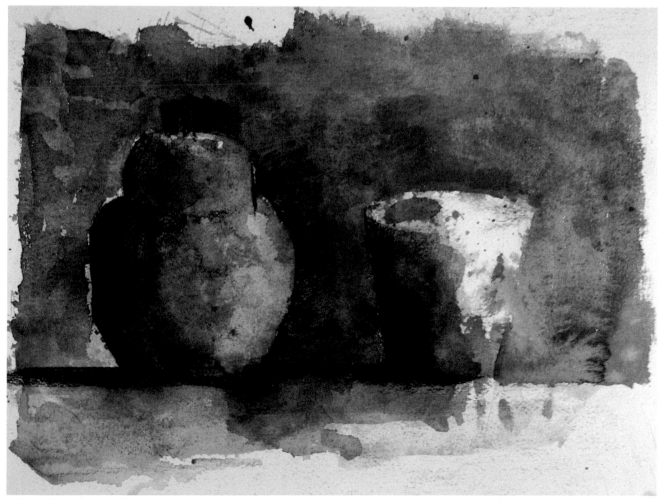

Michael Crespo, *Two Objects*, 9″ × 12½″ (23 × 32 cm)

I did not intend to limit myself to two colors—manganese blue and cadmium red—but in the act of painting this work, I found the two colors adequately explained the subdued light that filtered under the portico. I began by mixing a dark with the two colors and did a monochromatic underpainting, much as on Day 8. I then applied a diluted flat wash of the blue, blotting with a tissue where I wanted a highlight. After this dried, I repeated the light, flat wash with the red, again blotting the highlights. At this point I was shocked to realize that I was finished—one of the most pleasant surprises of painting. The colors had permeated the grays in the wash process and remained intact in the light, blotted areas.

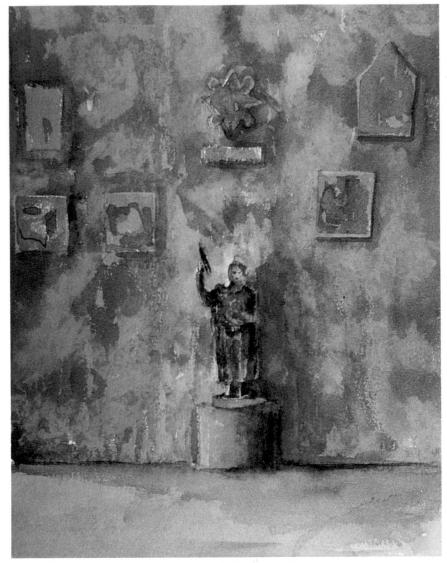

Michael Crespo, *In the Bargello Courtyard, Florence*, 15″ × 11″ (38 × 28 cm)

Joel West chose burnt umber and cerulean blue as his two colors and worked primarily with subtle gray mixtures. The objects he selected to paint warranted such metallic colors. Notice that the grays move back and forth from warm to cool, in this way aiding the very competent modeling. At some point Joel decided not to use the pure burnt umber anywhere, but to lean the color toward blue.

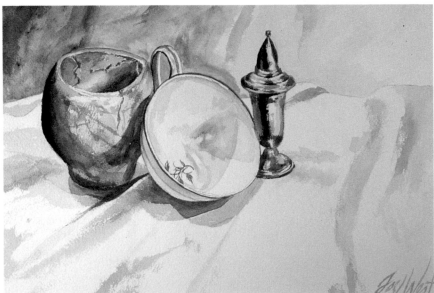

Joel West, student work, 9″ × 13″ (23 × 33 cm)

Libby Johnson Crespo, *Portrait of Angel*, 12″ × 10″ (30 × 25 cm)

Amazingly, this dog portrait is made with only two colors: black and burnt sienna. My wife Libby first laid down a diluted wash of sienna. She then laid black in to describe the dark areas of head and nose. For the fawn-colored muzzle and throat, she used sienna, modeled with a trace of black. She made the rest of the middle grays with a mixture of the two colors and left the white paper for highlights on the collar and nose. Despite the restriction, there is more than adequate color.

DAY 18
Plans and Variations

I am sure there has been a time when you labored over a drawing until it came close to perfection. With boundless optimism, you began to paint. Somewhere—through a misjudged color, overworked volume, or unexpected spill—you failed, reducing the paper to garbage, never to retrieve that splendid drawing.

Today we'll look at an alternative practice: the drawing plan, or master drawing. The idea is to make a drawing that is transferred to another piece of paper before it is painted. The drawing remains intact to be reused again and again. A note of caution, however: this way of working can be dangerously stifling. I do not recommend it for everyday use, but it does have its just application. If, for example, your subject is highly detailed, it may be impractical to draw directly on your watercolor sheet, especially more than once. Or there may be a subject you may want to paint in a series, perhaps performing color variations on the same form. I sometimes find myself with one chance to paint a subject—for instance, a freshly caught trout. After making a master drawing, recording color notations and perhaps painting a sketch on the spot, I bring everything back to my studio for deliberation and perhaps a grander attempt.

For the drawing, find a paper opaque enough for you to draw comfortably on, yet transparent enough to let a little light through. (I use index stock.) Use a pencil so you can easily make corrections and modifications. The only other equipment you'll need is a lightbox. If you don't own one, there's always another way. I've been known to tape the drawing and paper to a window for tracing. Of course this only works in the daytime. One night, however, I simply illuminated the room, went outside, and taped the drawing and paper to the other side of the window. The mosquitoes proved the only problem. Even better is a glass-top table with a lamp placed underneath. You may upset the decor of the room, but you'll have a real lightbox.

There's no set subject matter for this exercise—it's time you took on some responsibility! If you're desperately uninspired, go back and find a motif from a past problem that you were comfortable with. Minor alterations to a still life or a different point of view in a landscape can engineer an entirely different set of concerns. Whatever you decide on, seek out and draw an obsessive amount of detail. Editing can take place during the transferral. Make the drawing work as a drawing—do not just consider it a sketch for a watercolor. It may include value, or it may just be linear. When you're finished, go over it with pen and ink, or a marking pen, to facilitate tracing.

Transfer the drawing to a sheet of watercolor paper, and do a painting in front of your subject, observing it directly. Either today or in the near future, trace another drawing from the master and work on it without the subject. The first painting will be your only reference. In this second variation, do something different: perhaps changing the dominant color or technique, or exaggerating the light, or even utilizing a completely irrational color system. It's also possible to vary the original drawing. This is easily done when tracing, and is sometimes a necessary stimulus to the boredom of copying. Whatever you do, try to maintain a sense of spontaneity. It's all too easy for dullness to slither into this "once-removed" painting.

SPECKLED TROUT
(ERISCION NEBULOSUS)

This is one of many drawings that I keep on file for possible paintings. Usually I use pen and ink for this kind of drawing, but here I used a soft ebony pencil— it just depends on what's at my fingertips. I made this particular drawing from the fish itself, but did the three paintings shown here at different times.

In this, the first painting that I made from the drawing plan, I worked directly from the fish, which I lit in a very even manner. I fully intended for this painting to serve as a reference for paintings to come, which accounts for the rather tight-fisted rendering, done entirely on dry paper.

A year later I pulled out the original drawing and painted two new variations of the same fish (shown below). This time I wanted to show the fish underwater. I figured that with a couple of washes, the static fish would begin to swim.

After transferring the drawing, I wet the paper and laid in an irregular viridian wash. I allowed it to dry, carefully wet the paper again, and laid in another irregular wash, this time with ultramarine blue. When it dried, I began to paint the fish over the washes. I used much more color and a greater value range in this painting; I also worked wet-in-wet in the first few stages. Incidentally, I had to work to get the two drips at the bottom. Sometimes I'm more involved with these little maneuvers than I am with the subject.

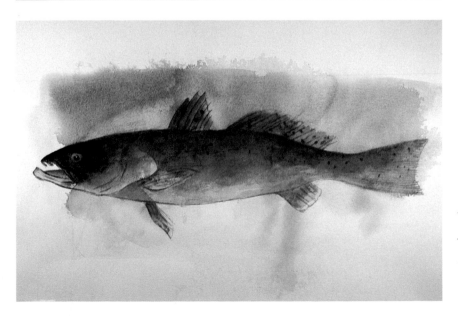

Once again I traced the original drawing, this time manipulating the lines and proportions of the original to establish a more menacing expression. I had already decided that this fish would be dark, red-eyed and red-mouthed, swimming in a gray sea. I painted the fish first with a number of glazes, establishing the dark top in contrast to the warm red-orange underbelly. When this was dry, I carefully brushed in an area of clean water, gently stroking with a large, soft brush so as not to disturb the pigment of the fish. I then brushed a gray of burnt sienna and phthalo blue across the top and, following the irregular wash technique, allowed it to fall down the page, encasing the trout.

This painting was made from a pencil drawing for obvious reasons. It took me a while, with much erasing, to sketch the intricate rigging of the boat. I only intended to make one painting, but with confidence waning, the security of a drawing, in case of failure, seemed appropriate. I grappled with the painting, wash after wash, and was disappointed with the outcome (which is how I usually feel after a struggle). I thought I had overworked it—the most common malady of watercolors. Two days later, I loved it. But I also began another attempt immediately.

Michael Crespo, *Sailing, Variation 1,* 11″ × 15½″ (28 × 39 cm)

At the time this version sat a little better with me. Sometimes, but definitely not all the time, the second variation flows more easily from the brush—the first endeavor being a learning experience, the second a spontaneous enactment of that knowledge. I did not work this painting as much, and the more decisive marks and color give it a livelier tempo and light. In the end I don't really know or care which is the better version. I'm happy with both, and I only had to labor over a drawing once.

Michael Crespo, *Sailing, Variation 2,* 11″ × 15½″ (28 × 39 cm)

Juanita Cacioppo, *Drawing Plan for Anemones*, 13½″ × 20″ (34 × 51 cm)

Juanita Cacioppo's drawing is a wonderfully alive study of shape and value pattern, as well as line. She used marking pens, whose slippery movement encourages animated work. Notice how the blue and black shapes, as well as the uncolored areas, suggest possibilities for not only a general value scheme, but also figure-ground relationships and perhaps color changes. There is a world of information in this drawing, quite different from the simple line studies that I use. Curiosity led me to lay this drawing on my lightbox and slip a piece of paper over it, just to see how it would work. I found a pool of options.

Juanita Cacioppo, *Anemones*, 13½″ × 20″ (34 × 51 cm)

I was at first surprised to see this delicate offspring from Juanita's rambunctious drawing. Yet, in comparing the two, you can see that in most areas the structure is identical, despite the major editing, especially in the background landscape. The space, however, changes drastically because of the color. As the intensity of the reds and greens shifts, there's a back-and-forth spatial movement.

It's clear that Juanita and I work quite differently from drawing plans. She makes ambitious, crammed drawings and selectively composes from them. I make spartan contour sketches and expand on them in the paintings. Both are options to consider.

115

DAY 19
Gouache

Often my students, despite my warning, can't live without using a tube of Chinese white. It's the conditioning from oil and acrylic painting. I hope that for the most part you hid it in the bottom of your box, so you were able to experience the wonder of light living in the paper, shining up through layers of transparency.

Today we'll examine gouache as a medium in itself and as a slight variation of *aquarelle*, or transparent watercolor. Gouache is the result of introducing Chinese white into the transparent watercolor palette, providing an opportunity for opaque value modulation. There are pigments designated "designers' gouache" or "designers' colors." Like the paints you've been using, these are ground in a gum-arabic vehicle. Gouache colors, however, usually have more pigment ground in and sometimes chalk is added for greater opacity.

In addition to gouache and watercolor, there are some other water media still used today. With *distemper*, the pigments are ground in gelatin or rabbit-skin glue. These colors dry immediately and are very matte, but brilliant. *Egg tempera* uses the yolks of eggs as a vehicle for dry pigments. The painting process involves a tedious layering of crosshatched underpaintings. *Casein* is a milk product used to bind colors. The effects are similar to those of gouache. Gouache, however, tends to be picked up with subsequent layers of paint, while casein is waterproof when dry. Finally, there is acrylic paint—a relatively recent development.

As I mentioned earlier, gouache involves using Chinese white to tint your watercolor pigments. To a certain extent, then, you can paint over mistakes. You can also combine techniques, continuing to utilize the paper as a source of light and creating lights with the white pigment. For a different technique, begin by priming your paper with a coat of Chinese white; then go about making a traditional watercolor painting on this surface. The white paint will lift up into your painting, giving the opacity of gouache.

Use the two techniques for two different paintings. With the first—combining opaque and transparent passages—paint one of the following motifs: a fantastic animal in an ordinary environment, an ordinary animal in a fantastic environment, or a fantastic animal in a fantastic environment. Interpret this in any way you feel suitable and, above all, have fun. For the second technique, when you prime your paper, do a variation on an existing masterpiece, much in the way Picasso painted from Goya, Raphael, Rembrandt, and Chardin. Work with a reproduction, but interpret it freely—you're meant to have fun, not labor over a copy. Just a stab at this problem will teach you about the structure of the masterwork. If you're still unsure how to begin this one, go to the library and study Picasso's variations—he painted hundreds of them.

Joel West, student work, gouache, 9" × 13" (23 × 33 cm)

This is Joel West's rendition of a fantastic animal in an ordinary environment. I think we can agree on the fantastic animal, although some may doubt the ordinary environment. The color is exaggerated, but the landscape is definitely Louisiana marshland. Besides, it's not critical that you translate this problem literally. It's intended for you to experiment with gouache, while extending your imagination.

Joel's use of Chinese white is especially obvious in the sky, where he layered the paint repeatedly, with definite opacity. Notice, too, how the gouache technique adds solidity to the land forms and "monster" in contrast to the water, which is handled more transparently.

Robert Warrens, *A Snake Posing as Uncle Sam,* gouache, 30″ × 22″ (76 × 56 cm)

George Chow has placed an unlikely animal in an extraordinary space. The top half of the painting, with its deep perspective, seems to collide with the enormous fish. The surface of the water then clearly divides two distinct spaces. A nice touch is the fin breaking the spatial barrier.

George has used the gouache heavily in modeling the fish's face and body, where chalky planes mark the volume. The milky cast to the water surrounding the fish indicates a mingling of Chinese white with the various colors, although their transparencies are still quite apparent. Don't feel you have to use the Chinese white in every color you use. It's best to mix various aquarelle techniques with different opacities of gouache.

George Chow, student work, gouache, 14½″ × 12″ (37 × 30 cm)

Robert Warrens is well known for his raucous compositions stuffed with raucous images. He needs an opaque technique like gouache for the massive buildup of marks and feeling of density in his zany visions.

On a compositional note, there's an intriguing ambiguity in this scene. The great red dog dominates the window view, but also breaks the frame on the right, entering our space. I'm especially fond of the quiet, tenderly modeled inkwell that sits in the right corner, in blatant contrast to the eye-ripping landscape.

Michael Crespo, *Study after Goya's "The Forge,"* gouache, 15½" × 12" (39 × 30 cm)

I practiced the second technique described on page 116 to make this study of the great Goya painting in the Frick Collection in New York—a painting that mesmerized me in my graduate school days, and still does. To begin, I laid down a fairly watery coat of Chinese white on hot-pressed paper, which does not permit much saturation, keeping the paint mingling on top. It's not necessary to use this kind of paper, but it works well. After this dried, I freely interpreted the Goya with ordinary, transparent colors. They picked up the white and formed a milky opacity.

My study loosely describes the forgers forging metal around a hot, red strip, which denotes a fire in the original. I, like Goya, have used the red as the primary focus amid a mass of dark shapes and men pounding hammers in a smoky room. Goya created the sense of atmosphere with color, while I have used texture. As I mentioned, the point is not to copy the masterpiece. Instead, this should be an exercise in interpretive expression, blasting off in any direction from an established composition.

This painting, also made with the second technique, is a variation on a different kind of masterpiece. It's a painting inspired by Wallace Stevens's masterful poem "Thirteen Ways of Looking at a Blackbird." I did not illustrate any particular lines; I just worked from a general feeling.

Here I used a heavy layer of white on the paper, which came up into the overlaid color and made it even more opaque, particularly in the multicolored underpainting of the birds. When I wanted less opacity, I stroked the paint on with delicate touch, without disturbing the underpainting. I also went back in with pure white in the background to cover some strong colors that I had placed adjacent to the birds. The opaque white is still transparent enough to allow them to be seen, as gentle currents beneath the surface. Finally, I used a thick white to delineate the jagged contours, central to what I wanted to say.

I strongly suggest that you try working from a poem you like. Poetry and painting share the same space.

Michael Crespo, *Two Blackbirds*, gouache, 11" × 30" (28 × 76 cm)

Melody Guichet, *A Woman Snipping Hair*, gouache, 11" × 15" (28 × 38 cm)

Melody Guichet is an expert in this variant medium. While she exploits the opaque buildup and more sustained execution possible with gouache, she does not abandon the translucency of watercolor. Here she has juxtaposed labored, opaque volumes on an equally labored, yet opalescent, mosaic field. The value variations, as well as the clustering of the little squares, gives the grid a rolling feeling.

DAY 20
Composition and Beyond

Most of the time we think of composition as simply the placement of shapes and colors in a two-dimensional field. Although this is a very important consideration, it is only a partial definition. I would define composition as *all* that makes up a work of art: the balance, rhythm, domination, harmony, and contrast of line, value, color, texture, shape, and subject. As painters we seek to express our most personal visions by assembling and organizing these elements in different ways. Somewhere in the process of juggling these visual elements, the painter's spirit is imprinted on the whole, creating an energy that distinguishes art from illustration.

To reiterate and expand on the many aspects of composition you've encountered in the preceding lessons, I would like to discuss some of my own paintings, as well as those of other professional artists. These works represent diverse styles and techniques, but even more they reveal the individuality of each artist, with his or her unique comprehension of art-making.

I don't intend to dwell on every element in these paintings; instead, I hope to give you a sense of what I consider the major concerns, not only when I make a painting, but also as I study the works of others. It is important to allow the work of other artists to inspire, if not influence, your own. Approaching other paintings with an open and constructive attitude—and not just as something to copy—can substantiate and brighten your own ideas and images. To get you started in this direction, I've suggested some exercises, derived from the paintings shown here. You might also try to design some problems of your own. My wish is that you will tap the enormous pool of options available every time you touch brush to paper.

This tiny painting depicts one of the many little statues that adorn the major fountain behind the Palazzo Pitti in Florence. I feel that the extreme drama of the blackened green against the paper-white edge of the sculpture sharply contrasts with the lack of focus and close values in the little cupid and the foreground. I am very fond of this and other miniature paintings I made during my stay in Florence, and it discourages me to see the emphasis placed on full-sheet works by jurors of watercolor shows these days. Don't ever fall for such a false standard. Let your instincts and subjects dictate the size of your format. Making symphonies does not necessarily mean you're making music.

Exercise. *Seek a subject that you feel would be comfortably presented in a tiny format. Paint it in a format where the largest dimension is no greater than three inches.*

Michael Crespo, *Putto, Boboli Gardens*, watercolor, 3¾" × 3½" (10 × 9 cm)

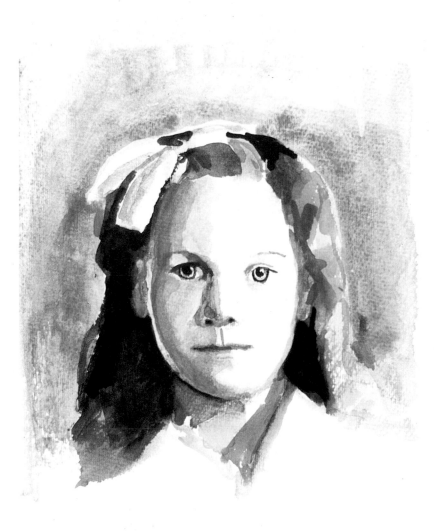

My wife Libby made this decidedly planar study of a young girl's head for a large oil painting. The articulated planes each play very specific roles in moving the eye around the head and explaining the surface contours. The strong, light blue streak down the girl's right cheek not only is a surprising focal point, but it joins with the blue plane of the nose and the grainy, blue background in line with the expanding color principle of Day 15.

Notice, too, how the hair augments the back-and-forth spatial movement. On the right the orange and sienna tones shove forward, appearing on the same plane as the eyes, while on the left the dark, flat shape is trapped back behind the ear and the graduated planes running from forehead to the cheek. The flat hair plane abuts the dimensional, multiplanar side of the face. The multiplanar hair area presses against a flat facial plane. These contradicting placements intensify the volume of the head by forcing the eye to move back and forth across the form, trying to unite the separated planes with their counterparts.

Libby Johnson Crespo, *Study, Leigh Hansbrough*, watercolor, 14″ × 9½″ (36 × 24 cm)

The light-drenched glimpse of an anxious dachshund is another example of wise plane location. We move into the space on planes of varying color. Look first at the paper-whites, which move from the dog's back to the chair top and on to the horizontal in the left background. Ironically, the other spatial transport is the black, which streaks us back from the bottom left, through the dog, to the chair, and back to the square in the background above the puppy's head. The colors then complete a powerful three-part scheme used by many artists to evoke harsh light and exaggerated contrasts: black, white, and color in close to equal portions.

Exercise. Crumple a piece of white paper and place it under a lamp or another direct light source. From any point on it begin a pencil drawing directly on watercolor paper, carefully delineating and connecting the planes. Fill your page with the planar subject and paint what you see using black, one other color, and the white of the paper.

Libby Johnson Crespo, *Chris*, watercolor, 6″ × 9″ (15 × 23 cm)

This enthralling little still life is intensified by a rich, grainy surface with an unusual dispersal of pigment. Jean Wetta achieves this effect by first priming the paper with an acrylic medium. This prevents any saturation of the paint into the surface and causes it to move and dry in mysterious ways. She has made ample use of this effect in the tabletop, where the strong, controlled reflection of the vase is flanked by a subtle buildup of illusive geometry, together depicting a convincing highly waxed surface. Additional texture is created when the paint collects in the brushmarks left during the sizing process.

Exercise. Choose a subject suited to a more textural treatment. Before painting, brush a coat of acrylic medium onto your paper and let it dry. You might experiment with various dilutions of the acrylic medium, as these will produce varying surfaces of color.

Jean Wetta, *Kalanchoe in Chinese Pot*, watercolor, 7″ × 5″ (18 × 13 cm)

I painted this studio companion very directly, with no preliminary drawing. With each new painting I try to discover something new about myself and the medium. In this one I held the brush in my awkward left hand and marked the cat's placid presence with quick, erratic movements. Meditating on the feline more than my painting, scraping and scratching my way to an image, I let some unexpected things happen. No matter how insignificant these things appear now, they were for me a minor triumph.

Exercise. Without making a preliminary sketch, paint any subject holding the brush in the hand you do not ordinarily use. Do not relent, even when painting the most minute detail.

Michael Crespo, *Ollie*, watercolor, 11″ × 15″ (28 × 38 cm)

124

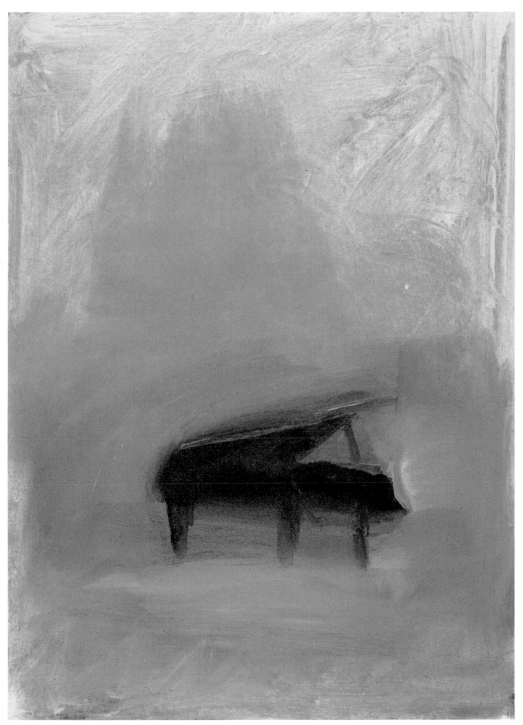

Edward Pramuk, *A Little Mozart Piano*, watercolor, 13″ × 10″ (33 × 25 cm)

This is one of a myriad of paintings Edward Pramuk has made celebrating the grand piano as form and instrument of art. In its shadowy simplicity it establishes itself in my mind as an intimate symbol of that moment when a young Mozart discovered the wonder of the piano. The mood is conveyed by the absorbing cobalt field, with the faint pentimenti of wispy reds and greens tracing beneath the expressively brushed surface. The contour of the piano is kept soft, merging with the background as if it were born of it. A soft, rubbed-out light becomes a curious cloudlike pedestal on which the massive weight rests, not in the concert hall, but in the artist's vision.

Exercise. Make a painting in which a solitary object or shape rests in a large field dominated by one color.

Lydia Bodnar-Balahutrak, *Study for "A Corner of Her World,"* watercolor and pencil, 7″ × 5″ (18 × 13 cm)

Lydia Bodnar-Balahutrak uses pencil shading worked into washes of slowly modulating color to cast an eerie light on this sobering scene. The areas of white paper divulge lines of perspective, creating a relatively deep space, which houses the woman. Her backlit figure is central and dramatic, yet it quietly slips back into the surface of the yellow-gray, L-shaped mass. Not only do the pencil strokes form a strong base for light, but they produce a texture that

fits the potent and mysterious narrative of this study.

Exercise. On Day 8 you painted a still life by first making an underpainting in grays, over which you glazed transparencies. Today, make a finished line and value drawing directly on your watercolor paper. Use a pencil or a pen and waterproof ink. Glaze transparent washes of color over this drawing as you did when you painted over the grisaille.

Robert Hausey, *Portrait of Sujata*, watercolor, 16″ × 12″ (41 × 30 cm)

Compare this portrait by Robert Hausey with Edward Pramuk's piano on page 125. In a sense, one is the reverse of the other, presenting the two extremes of how a single mass can relate in scale to the edges of a painting. Robert fills the paper with his single subject, a classically proportioned head, formed of simple geometric solids. The size of the head is exaggerated by its relationship to the edges of the paper, causing the soft, pensive gaze, limited color, and quietly modeled planes to seem much more forceful.

Exercise. Make a painting in which a solitary form occupies a clear majority of the paper.

My primary intention in this painting was to avoid the usual compositional tactic of containing the entire fish within the edges of the paper. So I began by radically (in my mind) drawing half of the fish entering from the right edge. This set the tone for the rest.

I was always taught that if you cropped an object, the mind's eye would continue the form outside the format. I believe this is true, but one of my major meditations when painting these underwater pictures is that I am painting a complete space, like an aquarium, comfortable and contained on all sides. Cropping violates this drastically. Determined to resolve this, I devised the confrontation of the fish with its prey, the shrimp. This little life-death drama commands the center of the paper, offsetting right-sided placement of the fish.

To enhance this effect, I faded the focus of this fish as it moved closer to the edge, pushing the image more to center. I then dampened the paper and laid in a wash, diminishing it slightly in value as it approached the center. Next I turned the painting upside down and made an emphatic graded wash, also bleeding to light at the center. I might add that to create the scratchy texture of the fish and shrimp, I used a duck's feather I found by a lake.

In the second variation of the theme of the big fish with the little prey, I was content to contain the dominant actor in the center of the composition. Notice that the storyline of the big fish chasing the small one occurs within the basic structure of an orange stripe in a soft, cool field. The larger fish was begun wet-in-wet and then resolved using a stiff bristle brush, of the kind usually used in oil painting. This brush gave a slightly variant mark, freeing the edges of my strokes. The wash was once again graded from bottom to top.

Exercise. Draw a composition in which the majority of objects and shapes are cropped, or situated at the edges of the paper. As you paint, remember that you must keep the viewer's eye moving within the format, so it doesn't escape at the edges.

Michael Crespo, *Feeding 1*, watercolor, 22" × 30" (56 × 76 cm)

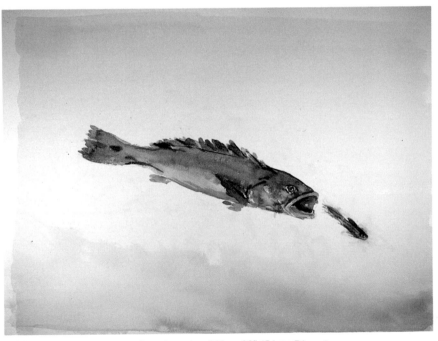

Michael Crespo, *Feeding 2*, watercolor, 22" × 30" (56 × 76 cm)

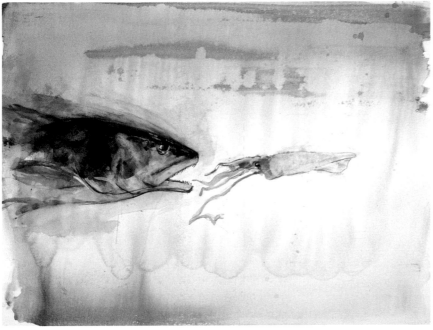

Michael Crespo, *Feeding 3*, watercolor, 22" × 30" (56 × 76 cm)

I often work in a series, painting variations on a theme much as musicians compose musical variations. In this way I get to know the subject and inherent problems more intimately; I also force myself to find different solutions and interpretations, if only to avoid the boredom of repetition.

Here I have repeated the basic theme of Feeding 1, but this time I have emphasized the graphic portrayal of the fish and bait by using purer colors and more distinctive line. I was very much influenced by the movement that color produces in Japanese woodcuts. I feel that the colored, gestural lines suggest the movement of a chase more than the rather still confrontation depicted in the first painting.

Michael Crespo, Feeding 4, watercolor, 22" × 30" (56 × 76 cm)

In this fourth variation I have increased the size of the fish in relation to the format and given it a diagonal pose, again to find more movement. Remember, it's my belief that diagonal lines are faster than horizontal or vertical ones. I have also used a different technique to arrive at a greater sense of volume. I laid down a number of layers of color on the fish until it was very dark and muddled. I then took a stiff, hog-bristle brush loaded with clean water and commenced scratching back through the layers and lifting out with a tissue. In some areas I scratched all the way to the paper. The result is a subtle, convincing volume.

Exercise. Do a series of at least five paintings, exploiting a single theme. You might, for example, work from a still life, keeping the objects in the same position while varying the other elements of the painting. Or you might vary the positions in each painting, or you might do both. The variations may be subtle or drastic.

Juanita Cacioppo, *Landscape, Late Afternoon,* watercolor, 14" × 21" (36 × 53 cm)

This fine practitioner of traditional watercolor has taught me much about the medium and inspired me even more. Juanita Cacioppo has been wetting brushes for many years, and I don't think there's any question about the practice of watercolor you can ask her that she can't answer. This landscape is a fine example of how to use temperature contrasts to explain space. The warm foreground plane thrusts cool shadows into the middle ground, which then dissipate into cool, deep, atmospheric space. The edges of forms also dissolve as they move to the rear of the space in what is known as atmospheric, or aerial, perspective.

Exercise. Find a landscape view with a deep space. Begin painting the space farthest away, letting the edges bleed together with little or no definition. When dry, layer the next zone of space on top of this one, painting the edges of forms with a little more delineation. Continue building the space, gradually letting the edges come into focus until they are harshly defined on the forms in the very front of the painting.

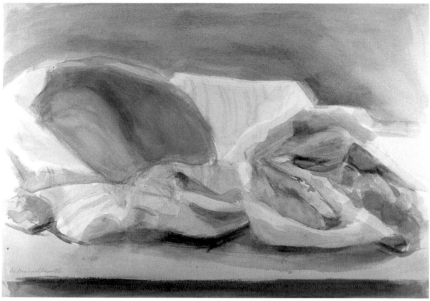

The amorphous objects of this still life lose their identity at the hand of this painter, but a sense of tranquil energy persists, as they seem to crawl across a comparatively distinct table plane. I have always envied Stephanie DeManuelle's gentle markings and colors, and how they extrude a rarefied presence from the carefully chosen objects she owns and confronts. Transparencies are beautifully layered, and warms and cools define the objects and folds, locking together into one large glowing mass. This particular structure results from a very thoughtful control of the edges of forms. These boundaries can be very significant in controlling the flow of space in a painting as they are eroded away or strictly enforced.

Stephanie DeManuelle, *Still Life with Melon Shell*, watercolor, 13″ × 19″ (33 × 48 cm)

The edges are more distinct in this version of the same still life. The smaller, cool grouping on the right defends against the pressure of the larger warm shell with a shield formed by a fold of drapery and its diamond-shaped recess. Observe how Stephanie fades the top edge of the mass into the white, implying its continuation into the space.

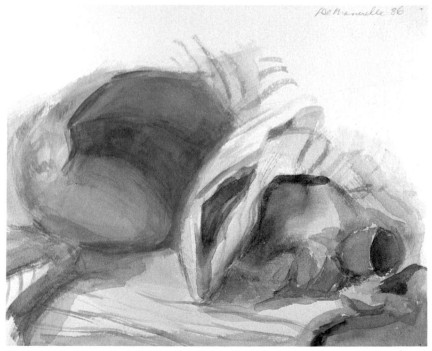

Stephanie DeManuelle, *Still Life with Melon Shell II*, watercolor, 8″ × 10″ (20 × 25 cm)

These curious figures, toiling at mundane chores, seem to be locked in their space and situation by the dazzling grid manifest in so many of Melody Guichet's paintings (see also page 121). The repetitive structure of a grid can be found as a principal motif in the decorative arts, as well as an emblematic framework in contemporary abstract art. Here it establishes a kind of woven atmosphere connecting disparate objects and events. To me, the blatantly distorted cup and saucer suggest that the field may be some uncanny time zone, forcing three disjunctive moments into proximity. In any case, Melody shrewdly juggles the values and colors of the grid to produce an inner light, layers and gaps of space, and nervous optics.

Melody Guichet, *Woman Combing Her Hair*, gouache, 11″ × 15″ (28 × 38 cm)

Stella Dobbins floods her paintings with repetitive patterns, which form an underlying gridlike structure. She develops the patterns by laying in multitudes of glazes; it takes her well over a month of steady work to complete one of her paintings.

This painting operates on several compositional levels. From one perspective we perceive the illusion of space, marked by the clever color and value changes from the reflective table plane to the hanging drapery. From another, the obsessive patterning of the drape and reflection merges into a continuous, gridlike field, on which the four animal objects are superimposed. And when we scrutinize the beasts, we begin to discern not only their geometric placement, but their visual and literal likenesses and differences, establishing yet another level. All these different compositional readings help to make this painting exciting to look at.

Exercise. Spend some time sketching shapes in your journal. They should be derived solely from your imagination. On your watercolor paper, plot and lightly draw a grid, which is merely a repetition of any type of shape. Situate some or all of the shapes you invent in the grid and commence painting.

Stella Dobbins, *Indian Still Life, or Homage to Mu C'hi*, watercolor, 26″ × 40″ (66 × 102 cm)

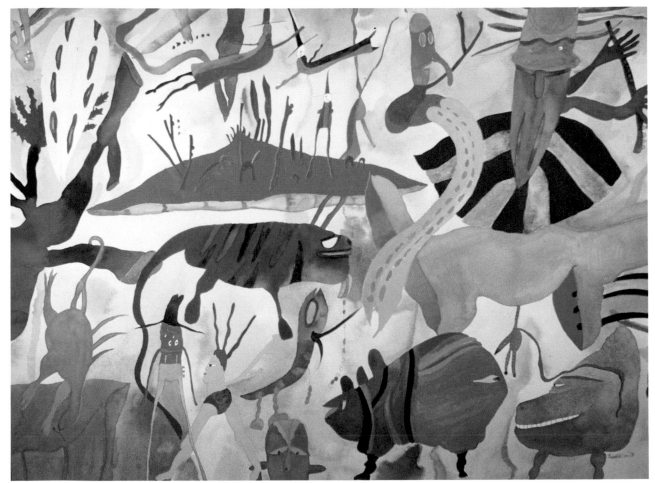

Barbara Lion, *Witches Delight*, gouache, 22″ × 30″ (56 × 76 cm)

Barbara Lion works almost exclusively in water media on paper. Spirited, visceral shapes in tumbling organizations always identify her wonderfully inventive paintings. The background for these frolicking creatures is set by the soft murmur of transparent wash transitions. The shapes of the dreamlike inhabitants then alternate between harsh opacity and modeled transparency, providing the volumes with curious spatial identities. This painting is also a fine example of the "varied color shapes on a gray field" scheme from Day 4.

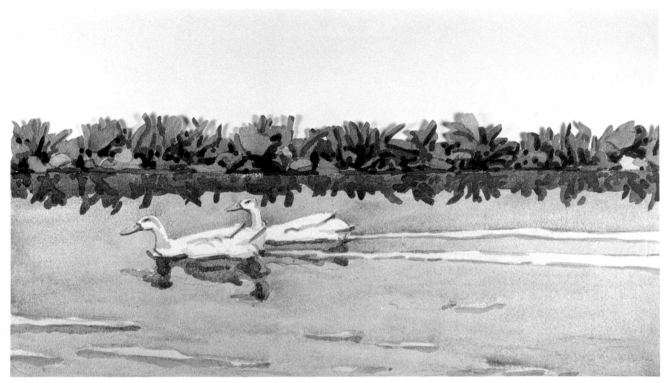

Orlando Pelliccia, *Pekins Study #2*, watercolor, 9″ × 20″ (23 × 51 cm)

This entertaining painting reflects Orlando Pelliccia's concern for the format as well as the three-dimensional illusion. The intricate edges of the waterplants along the horizon line form the top edge of the paper, for they have actually been cut away with a razor along their contour. It's an odd little surprise and gives the painting a slightly sculptural feel. The technique is well planned, economical, and painterly. Value and color are recorded with notable precision and describe the space with authority.

Exercise. Make a painting of your choice, but break from traditional formats. You may wish to use an extreme version of the rectangle as James Templer does (see page 136). You might also consider a circle or another shape, or you might cut away an irregular format with a mat knife as Orlando Pelliccia does. There is also the possibility of building a three-dimensional structure out of paper and tape, and then painting it. Whatever you do, be daring and keep tongue in cheek.

Orlando Pelliccia, *Untitled*, watercolor, 22″ × 30″ (56 × 76 cm)

Precise colors and values create the illusion of cut-out and pasted-down forms in this wash-day painting, even though it's painted on a standard watercolor sheet. It is, however, a study for a work in which the socks were actually cut out of plywood, painted as they appear here, and hung on real clothesline across the gallery. For a time, Orlando Pelliccia thrived on juggling illusions and realities.

In this painting Jean Wetta builds layers of transparent watercolor to produce a luxurious sky of billowing clouds. She facilely models warm violets to cool, making sensations of heavy volumes. The paper-whites ripple reflections in the sand, form whitecaps in the waves, and speak of sunlight in the sky. Earth, sky, and water attain a majestic scale with the appearance of the two small, brightly clothed waders in the surf. Try to imagine this scene without the figures and you'll understand just how much they contribute.

Not so long ago, while visiting James Templer in his studio, I immediately responded to this exaggerated format containing the vast panorama. The distant shore on the left exposes just enough of the tan color in the diagonal slice off the right corner to engage the two slivers of land in a conversation across miles of the expansive bay. Their scant, warm color is magnified by the luscious blue of everything else. But the prima donna of this painting is the playful, central cloud, which rises up with brattish aplomb, defying the compressed horizontal format and internal lines.

Jean Wetta, *Galveston Beach with Two Women*, watercolor, 7″ × 5″ (18 × 13 cm)

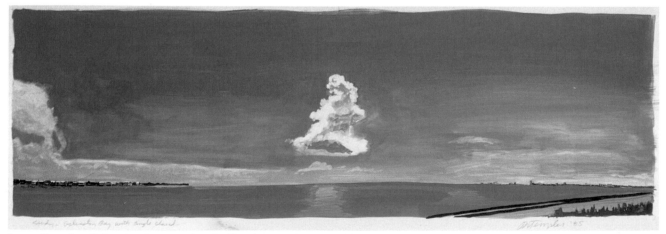

James Templer, *Galveston Bay with Single Cloud*, gouache, 7″ × 22″ (18 × 56 cm)

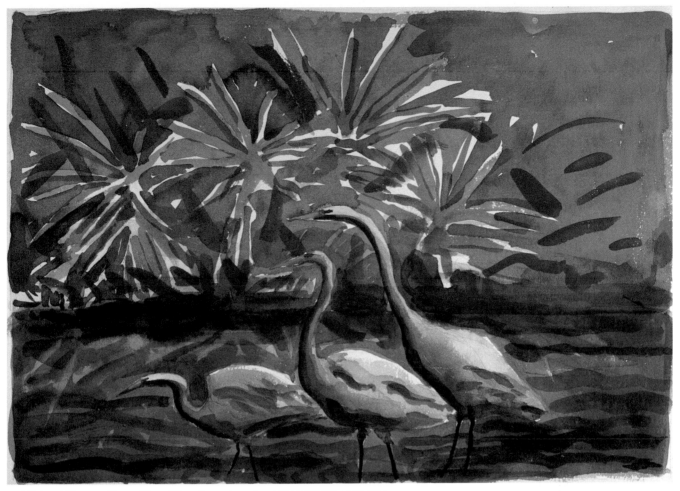

Michael Crespo, *Three Great Egrets*, watercolor, 14" × 20" (36 × 51 cm)

One of the benefits of living in Louisiana is that these magnificent birds occasionally appear in my backyard. A little lake attracts them, and when they arrive I try to paint or draw as much as I can. This painting began with two washes, one blue, one yellow, set side by side. The blue wash remains as the sky, but the yellow one lies beneath the birds and water. Some traces of it are still visible in the left center. The whites of the sky and on the birds were not masked initially, but just carefully worked around. As I painted, my interest seemed to shift from the birds to the surrounding palmetto leaves, which in the end became the dominant subject. Their jagged activity excited me more than the morose egrets.

Exercise. Look over all the paintings you've made so far and find one in which heavily articulated forms are surrounded by a relatively undeveloped background. Remake this painting, reversing the scenario. Let the background become the focus of your labor, the objects its aftermath.

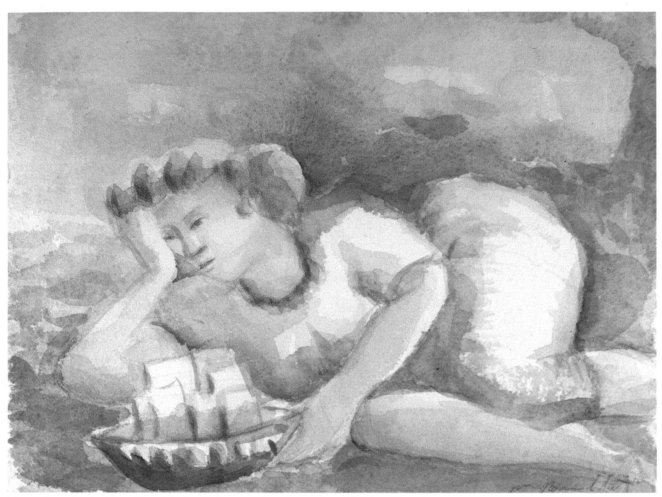

Marcy Rosenblat, *Going Through the Motions*, watercolor, 9½″ × 13″ (24 × 33 cm)

Marcy Rosenblat's distinctive limited color and close values might imply a restricted light, but by cleverly placing her paper-whites, she bathes this dreamy scene in a light very much akin to the steely whiteness that sometimes covers the landscape before a storm. Marcy builds her conceptualized, monumental forms with natural marks, growing out of wet washes. Her technique, limited color, and close value range all befit the dreamy substance of her narration. Also note the temperature changes, as small, warm areas are singled out in an expanse of blues.

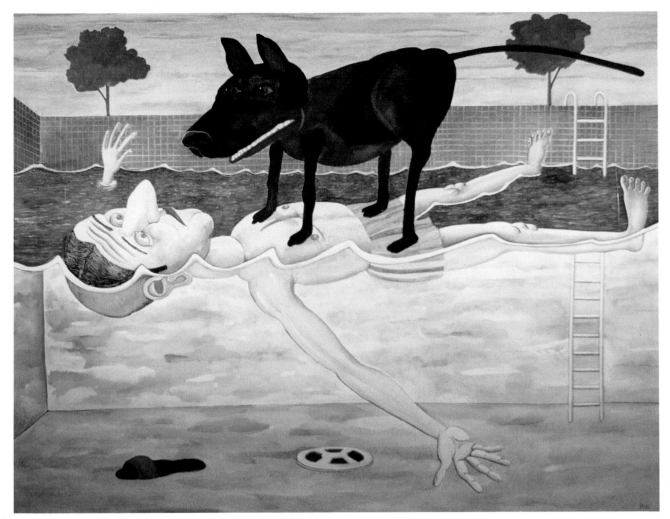

Robert Warrens, *The Swimmer*, gouache, 34″ × 43″ (86 × 109 cm)

Robert Warrens gives us a wonderfully warm and comic moment in this oversized celebration of man and his favored beast. Minglings of transparent colors adorn the water and the contrasting yellow sky, which, as you may have noticed, is transported forward, into the blues, via the striped bathing suit. Bob has constructed a vast space with abrupt and surprising scale changes. Chart the distance between the swimmer's hands. It appears even greater than the measurement of the landscape itself. The bath slipper on the pool's floor repeats the color of the dog, making their influence on the space uncanny. All in all it's a whimsical space, in which a waggish canine reigns with a bent scepter of a tail.

Exercise. Make a painting of your last remembered dream.

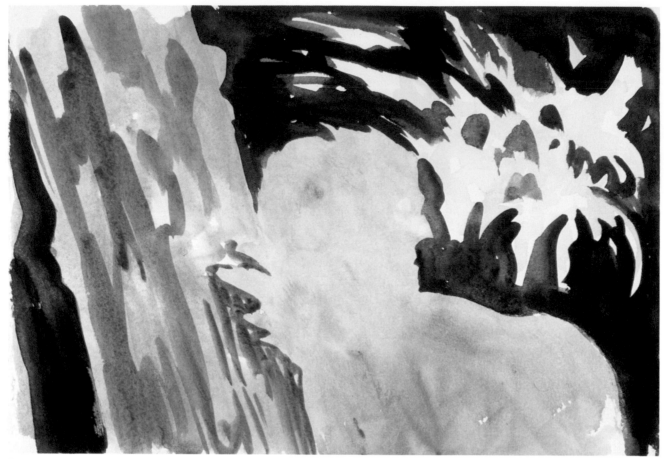

Jim Wilson, *Odysseus*, watercolor, 11″ × 15½″ (28 × 39 cm)

In this boisterous painting, Jim Wilson lays bare explosive shapes, presenting color in its most brusque condition—surrounded by black. Black paint symbolizes the absence of color and light, but when the colors of light are surrounded by it, as they are here, we encounter an extreme polarity, rich and exciting like fireworks in the night sky. The central figure of this composition slightly echoes the erratic edges of the yellow nova, while pressing violently against the green diagonal. Jim has given each shape its color through an understated technique, cautious not to vie with the cutting edges. Through this application of color, he also lifts these shapes, for moments, out of a constant figure-ground battle with the black. Here, simplicity breeds flamboyance.

Exercise. Do a painting of a group of flowers or some other fragmented, multicolored subject. Paint every inch of the surrounding background flat black. You may need to lay down a number of layers of black paint to get it flat enough.

Sam Losavio exploits literary themes and concepts in most of his work. Sophisticated treatises are rendered in almost primitive utterances. He reduces the medium to warm values of limited grays, but embellishes his digested stories with a rich vocabulary of compulsive marks and disquieting shapes. This painting began with a slashing wash, which cradles the two images that speak the foreboding passions of the mythic lovers.

Sam Losavio, *Tristan and Isolde*, watercolor, 22″ × 30″ (56 × 76 cm)

In another painting of literary origin, a tiny stick figure floats alone in space, a contrasting comment on the large massing of beings in conversation on the right. These beings are imaged in a surprising array of shape types: branching lines; a soft, swelling lozenge; flat, abrasive lozenges; and splattered drips—all drawn with a groping, sensitive hand.

Exercise. Reread a favorite poem. As you read, try to image colors and shapes. Record these sensations and use them to make an abstract composition. Do not be too literal with your shapes. Let them be enigmatic.

Sam Losavio, *The War at the End of the World*, watercolor, 22″ × 30″ (56 × 76 cm)

Index

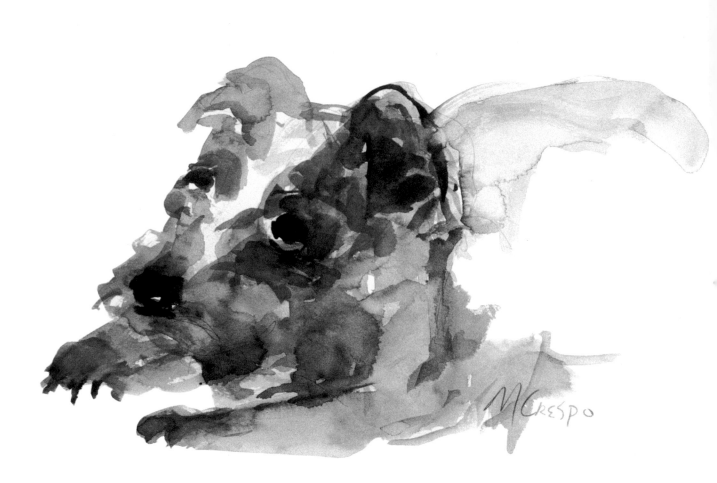

Michael Crespo, *Sparky*, watercolor, 10″ × 14″ (25 × 36 cm)